IMAGES
*of America*

# RED RIVER FLOODS:
## FARGO AND MOORHEAD

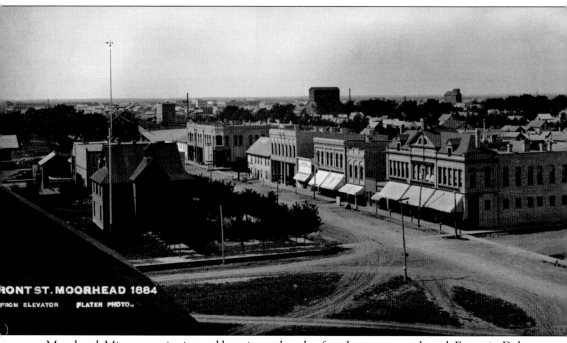

FRONT ST. MOORHEAD 1884
FROM ELEVATOR    FLATEN PHOTO.,

Moorhead, Minnesota, is pictured here just a decade after the town was platted. Fargo, in Dakota Territory, can be seen in the background, across the Red River. (Flaten image, Historical and Cultural Society of Clay County.)

ON THE COVER: Moorhead photographer Ole Flaten captured the tragedy of flooding and the hardiness of those who went through it in this 1897 glass negative shot. (Historical Society and Cultural Society of Clay County.)

# IMAGES
## *of America*

# RED RIVER FLOODS:
## FARGO AND MOORHEAD

Terry Shoptaugh

ARCADIA
PUBLISHING

Published by Arcadia Publishing
Charleston, South Carolina

Printed in the United States of America

Library of Congress Control Number: 2014942396

For all general information, please contact Arcadia Publishing:
Telephone 843-853-2070
Fax 843-853-0044
E-mail sales@arcadiapublishing.com
For customer service and orders:
Toll-Free 1-888-313-2665

Visit us on the Internet at www.arcadiapublishing.com

*This book is in honor of my colleague Korella Selzler, without whom
I could never have accomplished all that I have over three decades.*

# CONTENTS

# ACKNOWLEDGMENTS

This book of photographs is only possible because of the generosity of many people and organizations that helped with information and images. The Historical and Cultural Society of Clay County and their archivist, Mark Piehl, kindly provided access to a great many images from their collections. Similarly, the Institute for Regional Studies staff, Candy Skauge and John Hallberg, at North Dakota State University helped with some key images from their collections. The staff at the Northwest Minnesota Historical Center, Korella Selzler, Haley Nordskog, Nathaniel Craig, and Tyler Ostgaard, provided many images and materials. Darel Paulson and Ande Sailer, both of Minnesota State University Moorhead, added items from the university's collection of photographs, as did Lisa Sjoberg and her staff at Concordia College. Katelyn Fisher provided images of the flooding situation in Oxbow, while Julie Rasier permitted me to use images from her family's experiences in the 1997 flood. Ken Viser, Alan Fricker, and Oak Grove School also provided photographs. Minnesota Public Radio permitted me to use two striking photographs of very recent flooding. My thanks to all for their kindness.

The city governments of Fargo and Moorhead were generous with their own photographs. Special thanks as well to the federal agency photographers who did so much to document the most recent floods, often risking their safety to capture a moment that shows what a flood emergency really looks like.

Finally, appreciation as well to Arcadia's staff for their help and encouragement.

Photograph credits include the following:

Concordia College
Historical and Cultural Society of Clay County (HCSCC)
Institute for Regional Studies, North Dakota State University
Minnesota Public Radio
Northwest Minnesota Historical Center (NMHC)
Minnesota State University Moorhead
Oak Grove School

# INTRODUCTION

Some years ago, I spent a few weeks as part of a local committee planning historical exhibits for one of the area's museums. One of the exhibits concerned was "The Red River of the North—its place in the region's history." Several ideas were considered for showing how the river was a key part of the history of the communities sited along the Red's water as it twisted its way to Canada. However, I most recall the remark made by another committee member, who said, "We put Fargo and Moorhead here at this spot because that's where the railroad crossed the river. That was fine at the time, but now we'd actually be better off if the river wasn't here anymore. Oh, I know its water is still important for the farmers and all, but it's hard to think of that when you have to worry about a flood every five years or so."

I had not seen one of those floods yet, but the remark stayed with me. I grew up in a suburb north of St. Louis, about a quarter-mile from the west bank of the Mississippi. My father, who loved to hunt quail in the fall, used to take our pointer over to the brush in the riverside every autumn, so he and the dog could get in shape for the hunting season. With some earnest pleading on my part, he would let me go along, and on some of those walks he would talk about his memories of seeing the Mississippi in "full flood" in 1927. "That was a very scary thing to see, even when I was 10 years old and full of energy. As you watched that fast current, it just made you back away," he would say. He had seen one of worst floods in history. His parents had photographs of it. I used to look at them when I visited, and, like my father, I was both fascinated and uneasy to see so much water, obviously pushing ahead so fast.

Thirty years after those memories were formed, I came to the Red River Valley. It was in the late 1980s, and the climate was very dry. It remained dry for years. One time during that time, I had the occasion to be by the river with a colleague. "It's not much to look at, is it?" I asked. "If we can get a wet fall and heavy snow one of these springs, it'll look very different," he replied. In 1997, I found out what he meant.

On average, 89 Americans are killed in floods, and flooding does over $8 billion in damages each year. Deaths in floods of the Red River of the North are rare. The floods are not like the typical movie version of a flood; there is no rushing torrents from a broken dam like what leveled Johnstown in 1889 or a storm surge of water that leveled that of Galveston's in 1900. The Red River simply rises and spreads—and keeps spreading, farther and quicker than pumps can handle. A friend who had his home seriously damaged in the 1997 flood told me about his daughters: "While their mom and I manned the sandbags and checked the pump, keeping it out of the garage, our daughters were in the basement where water was seeping into one corner, not fast, maybe a glassful every five seconds. They used a wet-vac to soak it up and dump it in the sump pump drain. But it kept coming. They fought that seep for nearly 30 hours, and then we were all too exhausted to stop it. In the end, we got about five inches of water in the basement. I still can see my youngest, crying with frustration and defeat."

That was how the floods have gone, up and down the valley, as too much moisture pours across the flat, low countryside, sparking hundreds of dramas as the people along the Red and its tributaries fought, and still fight, the floods.

The photographs in this volume depict the floods that have imperiled Moorhead and Fargo, centering the image-narrative on the worst of the many floods that have occurred since the 1880s. Much of the material places the central focus on decisions that both communities have made over the decades to prevent floods from doing irreparable damage and the techniques that the community leaders have developed to combat the water once a flood begins. As the reader may see, "policy" questions continue to this day. When good images have been available, they document show how these major floods have affected individual homes and families at the ground level. A flood is a very personal experience, one that many cannot endure revisiting or discussing. News stories and official reports were helpful in providing a sense of the quantitative damage that each flood left in its wake.

It should be emphasized that these cities are just two of the many communities along the river. This is where the railroad traversed the river valley in 1871 and where the first two communities arose, Fargo in North Dakota, and Moorhead, in Minnesota. For various reasons, this is also where much of the national media looks in order to tell the stories of Red River flooding.

That focus is unfair in many ways, for flooding is a problem along the whole length of the river system. Communities like Breckenridge and Wahpeton to the south and Georgetown, the Grand Forks metropolitan area, and Pembina to the north of Fargo and Moorhead have had their crisis days and have their own stories to tell. No one who has lived in the valley has been immune from the damages inflicted by the floods.

For this reason, the book is published in honor of all those who have faced the Red River Valley floods. They all have learned that, while nature is kind enough to create such a place of beauty and bounty in which to live, nature also exacts a harsh price in return.

# *One*

# ORIGINS

Fargo and Moorhead came into existence in 1871, when the Northern Pacific Railroad chose its site for a bridge crossing the volatile Red River of the North. After purchasing land on the riverbanks, the Northern Pacific deposited $50,000 worth of federal land vouchers with the regional land office and then constructed the bridge spanning the river into Dakota Territory. It also built rail yards and its regional headquarters.

The Northern Pacific would exercise considerable influence over both communities for many years. As historian Carroll Engelhardt has written in his book *Gateway to the Northern Plains*, "Many Americans believed that where railroads crossed rivers, great cities might arise." The railroad's directors certainly hoped that would happen and that their businesses would benefit from such an outcome. Both towns were named for major stockholders of the company. Railroad investors were principal owners of many of the towns' early business establishments. The settlers, who soon flocked to the towns in order to claim homesteads nearby, had, as Engelhardt notes, "designs of their own." The Northern Pacific would not control everything.

Confident in the site they had chosen for their bridge, the railroad's managers eagerly anticipated the profits that would come from burgeoning commerce. The nascent settlers cherished high hopes for their own success in nurturing the land.

Fargo and Moorhead grew into the economic hubs of the region. Manufactured goods from the East came in, and the commerce enriched many of the two towns' founders. The farmers' grain in turn went east to feed the populations of the cities. (NMHC.)

The river was the primary mover of commerce at first. It cost about 10 times the amount to haul goods overland by horse as it cost to send them by water. The railroad would change this. (NMHC.)

As the rail lines grew, the railroads took over transportation for commerce in the Red River region. The river continued to play a major part in the timber industry in northern Minnesota, but this too would decline. Here, a worker unloads farm equipment at the Moorhead terminus in the late 1800s. (HCSCC.)

The timber industry was in full operation in northern Minnesota, near the Canadian border, in the late 1800s. Lumbermen often came to Fargo and Moorhead for rest and recreation after payday. Timber removal had the unfortunate effect of speeding rainwater into the rivers of the region. (NMHC.)

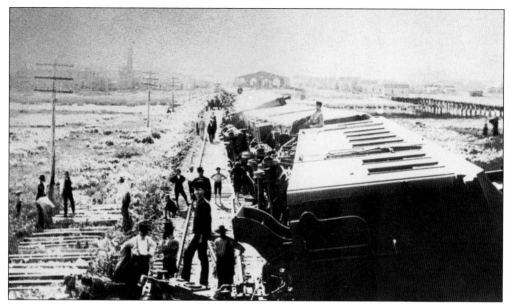

Volatile changes in the weather were common in the region. Here, a train leaving Fargo has been overturned by a tornado. Storms frequently damaged towns and devastated crops, but over time the major threat became the heavy spring floods of the rivers. (HCSCC.)

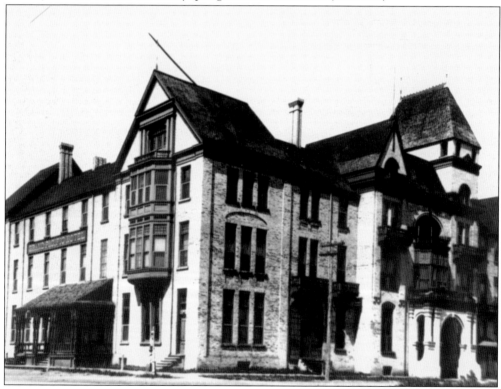

The towns built major public buildings and important businesses on higher ground. The Grand Pacific Hotel in Moorhead was sited over 200 yards east of the river to protect it from possible flood damage. (NMHC.)

Both communities had small police forces and fire companies. This is Moorhead Fire Company when it received new trucks. These services were not large enough to meet all the challenges that come from a major flood emergency. (NMHC.)

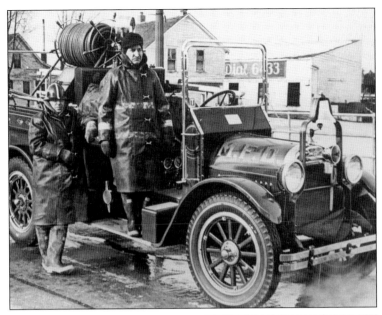

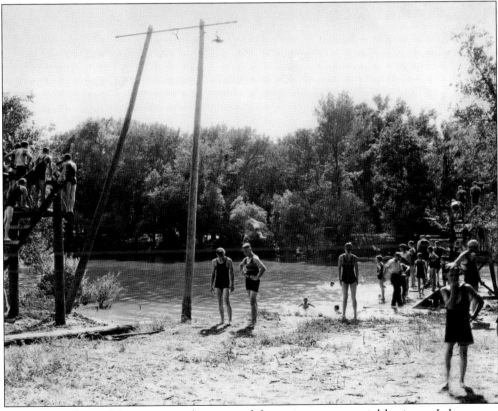

After 1915, the Red River was no longer used for serious commercial business. It became a source of recreation, such as canoeing, swimming, and fishing. Usually it posed little danger to swimmers, like the group of kids seen here. But after heavy rains or the spring melt, the river ran dangerously fast. (HCSCC.)

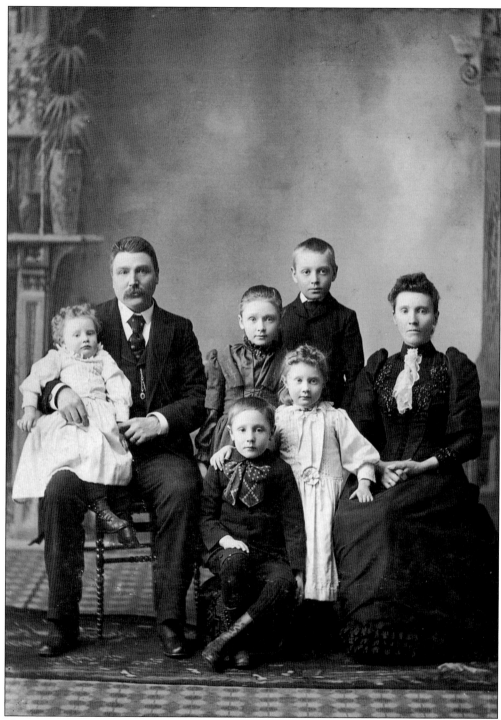

Photographer O.E. Flaten, seen here in a portrait with his family, opened his business in 1879; he documented the growth of Fargo and Moorhead. He was one of the most important figures to record images of the great 1897 Red River flood, which came close to washing away much of what the residents had built in their first quarter century. (NMHC.)

*Two*

# THE GREAT DELUGE
# OF 1897

When the Northern Pacific Railroad arrived at the Red River, the engineers selected a site for crossing the river that puzzled the few settlers living nearby. The banks of the river were very low, they told the railroad men; any towns built here will be flooded when spring comes. "Look around," they said, "the cart trails that go north toward the Canadian settlements run nowhere near this part of the river. The flooding would wash out the trails and flood any towns here. Put your bridge somewhere else." But, the engineers liked the site because the shallow water made it easier to sink the bridge's pilings, and river trade would develop more rapidly along the low banks.

So the towns of Fargo (in Dakota Territory) and Moorhead (in Minnesota) sprang up in 1871 on each side of the Northern Pacific bridge over the Red River. The towns and surrounding farms grew rapidly. But, the old settlers proved right about the floods. Between Moorhead on the Red River and the village of Detroit (later Detroit Lakes) about 50 miles east, land elevation dropped 400 feet into the river valley. Trying to create an easier grade for the train line, the railroad built an enormous embankment out of timber, rock, and millions of tons of soil. However, while this helped the Northern Pacific, it did nothing to stop the mass of water that poured down toward the river each spring.

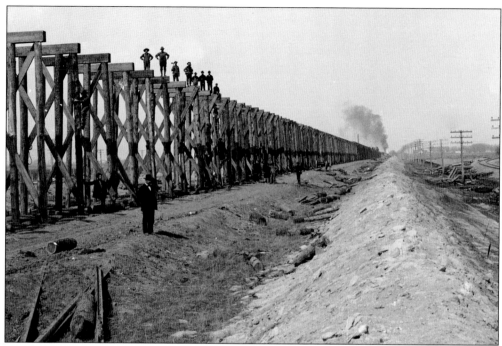

Northern Pacific engineers spent years building an extensive embankment to reduce the grade over which the trains had to travel in and out of the Red River Valley. (HCSCC.)

In order to cross the river, trains used the bridge that was placed well above the normal level of the water. In this particular photograph, the water is quite low, with almost no chance of major flooding. (HCSCC.)

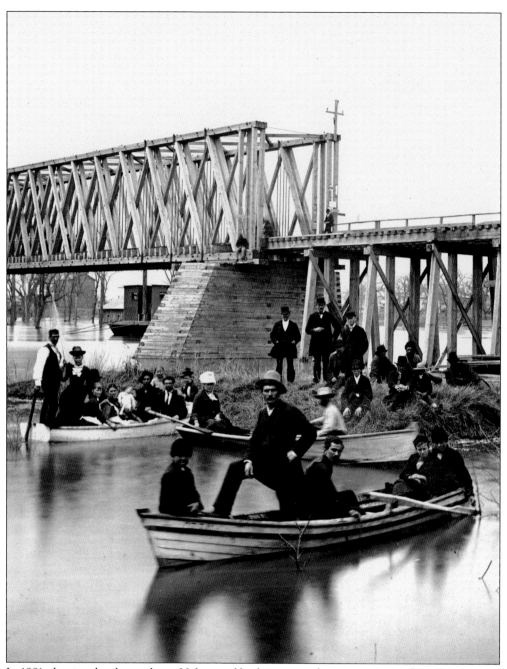

In 1881, the river level rose above 30 feet, and both towns took steps to protect the railroad bridge across the river. Despite serious damage to buildings and property, many residents took to boats to get a close look at the suddenly swollen waters. (Flaten image, HCSCC.)

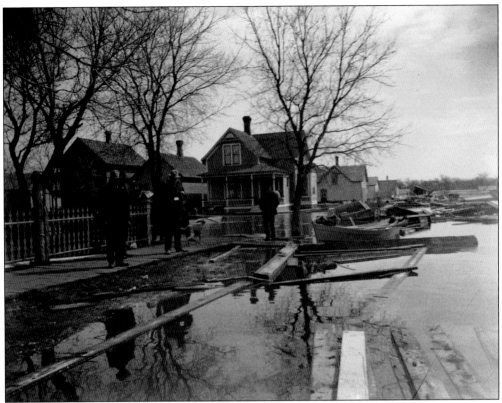

Homes near the river were ruined, and the streets were washed out by the 1881 flood. Debris littered both Moorhead and Fargo. Some people had to take temporary shelter on rooftops. Minor flooding occurred in years following 1881, and then the flood of 1897 struck. (Flaten image, HCSCC.)

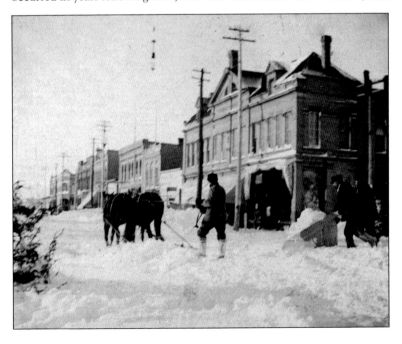

The winter of 1896–1897 was extremely harsh. It was difficult to keep roads and streets open. Usually, horse teams were used to level paths, and people traveled using sleds. (NMHC.)

"If all reports are true, there is more snow on the level now than there was in the spring of 1861. The snow measurement is two and one-half feet more snow than we had in 1861. Those facts prove that we will have a greater flood this year than in the history of the valley." This was reported in the *Fargo Forum and Daily Republican* on March 15, 1897. (Price Mackall image, HCSCC.)

The heavy piles of snow began melting in late March, slowly at first, but the running water accelerated as the temperature rose. By April 2, the Red River was rising faster than any resident could recall. (Price Mackall image, HCSCC.)

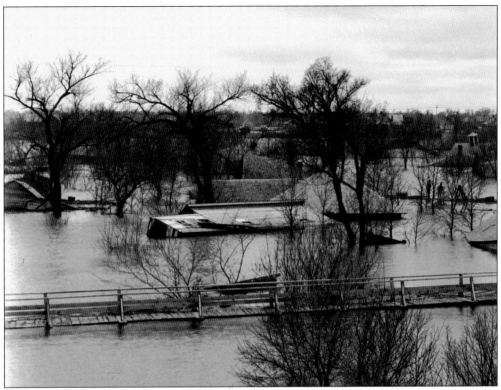

Floodwaters pooled in local parks, and the force of the water collapsed homes and businesses near the main channel of the river. The mayor of Fargo appealed to state and federal authorities for $10,000 needed for immediate relief of the flood victims. (Flaten image, HCSCC.)

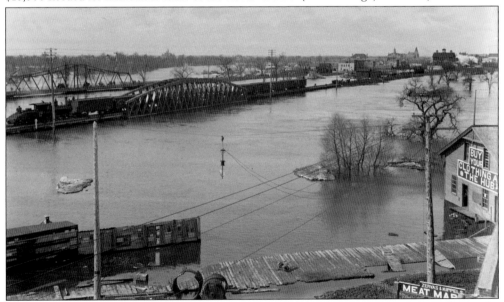

By April 7, the river reached a height of about 40.1 feet (river gauges were still imperfect at the time). This photograph was taken that day. The two towns were using railcars and farm equipment to anchor the bridges. (Flaten image, HCSCC.)

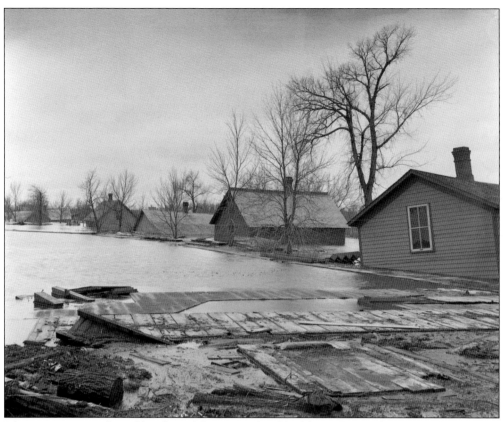

The river's unprecedented height and force inundated buildings close to the river and, as seen on the far right, pushed homes off their foundations. (Flaten image, HCSCC.)

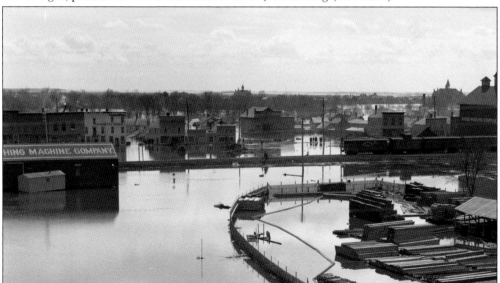

Dozens of dramas were played out as those who made their living from the river rushed to protect property. In this shot, taken from a grain mill's roof, lumberyards, rail property, boardinghouses, and stables are all at risk. (Flaten image, HCSCC.)

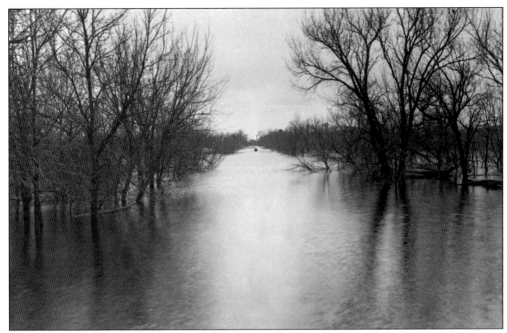

The water level rose so quickly that within three days the width of the river had more than doubled. Most of the walking bridges were inaccessible, and anyone who had to get from one community to the other had to rely on a boat. (Flaten image, HCSCC.)

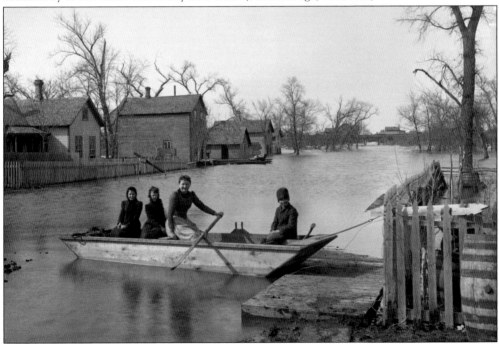

"There is much suffering among poor families. A relief committee operated jointly by the City Council and the County Commissioners, established headquarters this morning. Sections of the city which no one dreamed could be reached by the flood are now under water." This was recorded in a special dispatch to St. Paul from Fargo and Moorhead authorities. (Flaten image, HCSCC.)

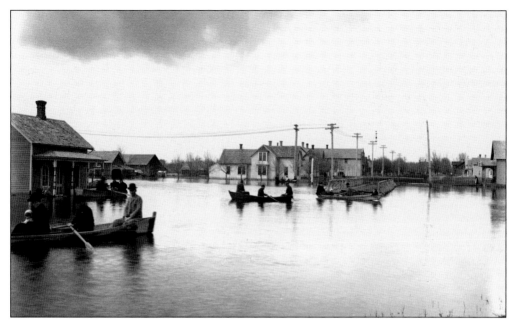

Fargo and Moorhead began to resemble Venice, Italy. Boats became the dominant method for getting from once place to another. This flooded section was on the north side of Fourth Street and Seventh Avenue in Moorhead, normally more than 400 feet from the river. (Flaten image, HCSCC.)

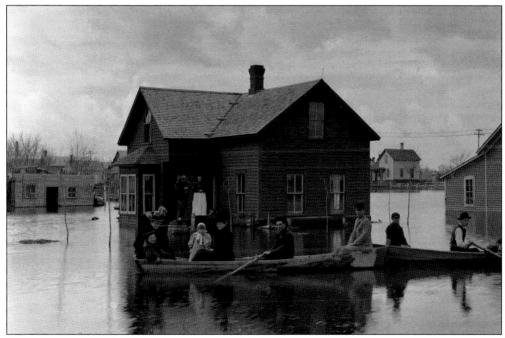

People adjusted to a water-borne life. Local stores obtained boats to deliver groceries and medicines, and neighbors tied boats together to socialize. (Flaten image, HCSCC.)

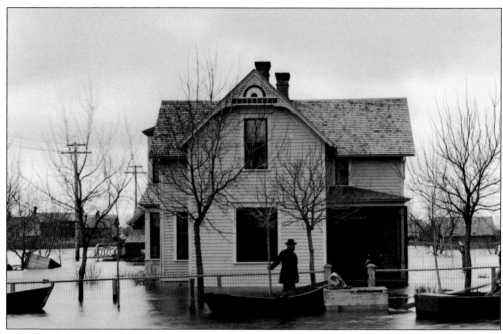

The Ole Martinson home was severely damaged and required extensive repairs. (Flaten image, HCSCC.)

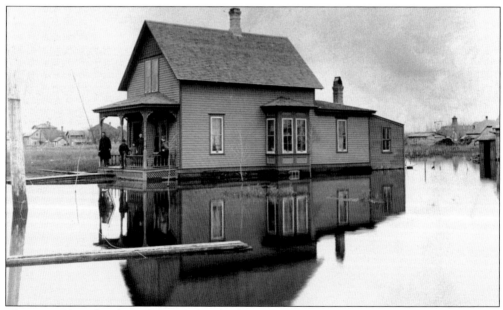

The Bottolfson family gathers on the porch of their home. It was common for families in these "island homes" to build temporary wooden walkways to use for reaching boats. (Flaten image, HCSCC.)

Fargo's damage was just as severe. R.M Price, a Fargo photographer, took this shot as the water reached its crest. Moodys Dry Goods Store was partially pushed off its foundations by the water. (Price image, HCSCC.)

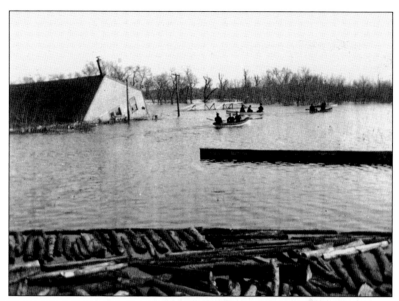

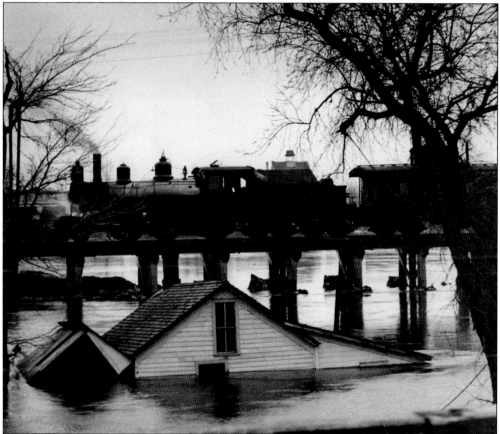

The Northern Pacific Railroad again protected its bridge with locomotives and loaded boxcars to anchor the pilings. A washed-out bridge would have disrupted millions of dollars of east-west trade. (NMHC.)

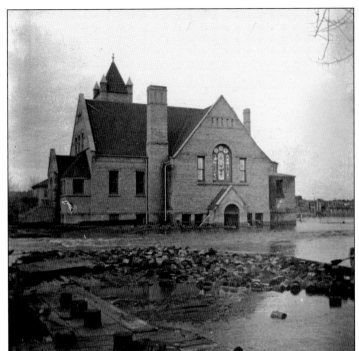

The Congregational Church in Fargo had its lower floor flooded nearly to the ceiling. The foundation was weakened, and much of the furnishings were ruined by water or humidity. Several streets in Fargo and Moorhead were paved with wooden blocks, which the flood lifted and scattered. (Price image, HCSCC.)

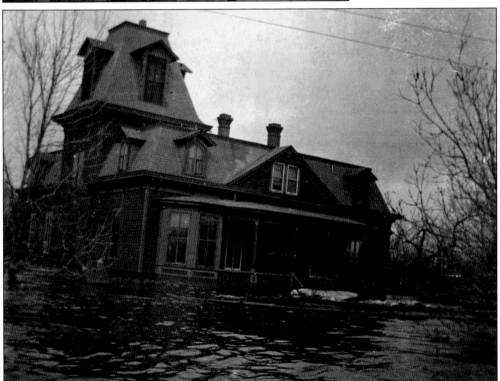

Price, or one of his assistants, probably took this shot from a rocking boat. The building served as the quarters for nurses of St. John's Hospital in Fargo. The building had to be significantly rebuilt. (Price image, HCSCC.)

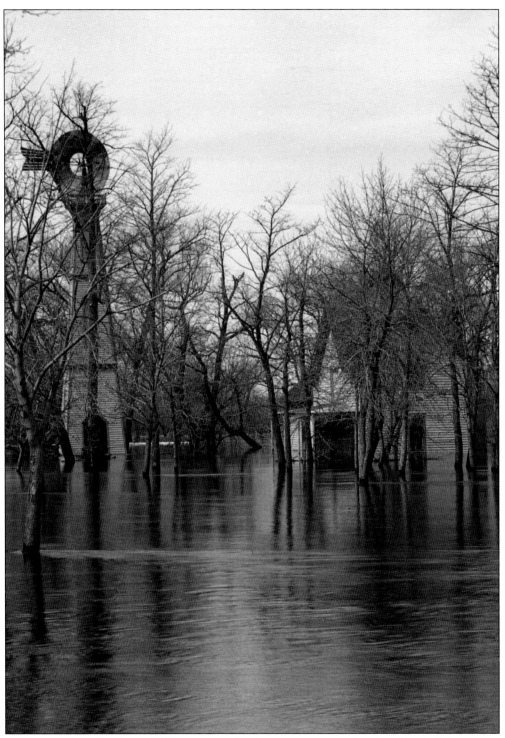

Farmers nearby suffered as well. Growing mostly wheat and potatoes, they found it vitally important to plant early. The flood delayed planting, and many farmers had hard times as a result. (Flaten image, HCSCC.)

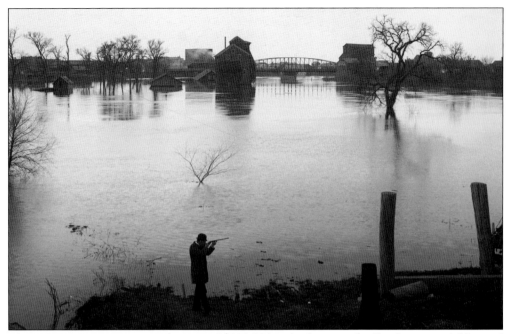

The US Congress appropriated a sum of $200,000 to both towns for flood repairs. Additional funds were awarded by the state governments to build dikes in the hope that another "catastrophic deluge" would never occur again. (Flaten image, HCSCC.)

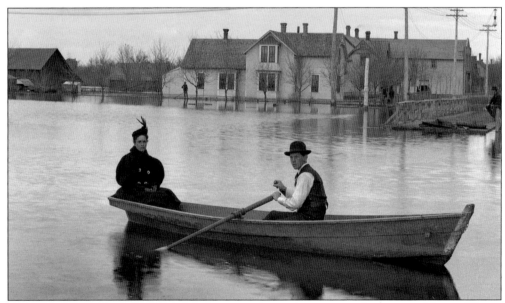

As the water level slowly fell in the river, people tried to resume their normal lives. (Flaten image, HCSCC.)

The 1897 flood left permanent marks on Fargo and Moorhead. Local banks, like the American State Bank seen here, urged patrons to buy insurance against damages from flood, tornadoes, and other natural disasters. (Flaten image, HCSCC.)

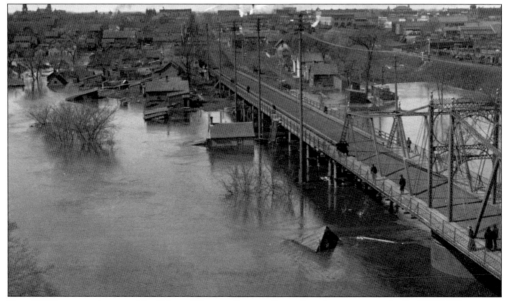

Post-1897 precautions paid off just 10 years later, when the river rose again in 1907. The water did not reach 1897 levels, and the new dikes reduced the damage. One of the more enterprising photographers even made commemorative postcards. (Onstine image, HCSCC.)

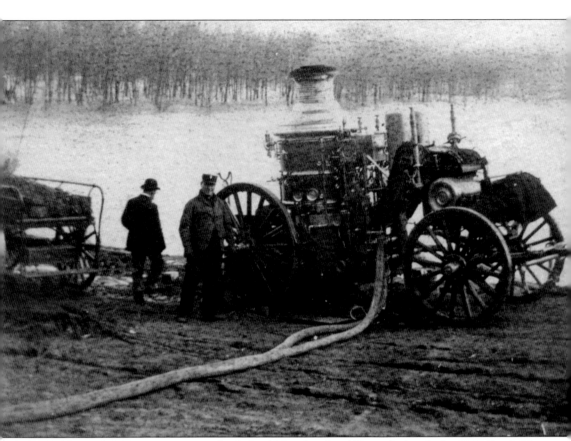

Additional pumping equipment also helped Moorhead and Fargo deal with the 1907 flood. City planners hoped that new technology might make it possible to better control the river. (Onstine image, HCSCC.)

*Three*

# CAUSES OF
# RED RIVER FLOODS

There are many detailed explanations of why flooding is so frequent in the valley of the Red River of the North. One study stresses the perfect synchronicity between the "runoff from the southern portion of the Valley as it progressively joins with fresh, melt-off waters from more northerly localities." Others note the heavy snowfalls and the varying gradient of the river as it flows north. Still, others stress that the cold weather, even during the early spring thaw, makes "ice jams" a serious problem because it backs up the current, causing pooling of the water in the narrow, twisting channel. What all these detailed analyses add up to is the simple fact that too much water ends in a narrow, not very deep river, which then overflows its banks, and slowly but surely the very flat ground in the valley floods.

Since Fargo and Moorhead—along with several other towns in the valley—were built along the river in order to increase the commercial trade, it was inevitable that the towns would be endangered by flooding at regular intervals. Naturally, as the towns grew, so too did the challenge of protecting the communities' facilities and the inhabitants from the damage of each successive flood.

This chapter uses images to show how the floods develop and how each factor in the water's rise simply increases the likelihood of severe flooding. Inhabitants of Moorhead and Fargo learned early that some level of flooding is a near-annual event. Experience has also shown that even the most ingenious innovations in technology cannot completely control the water.

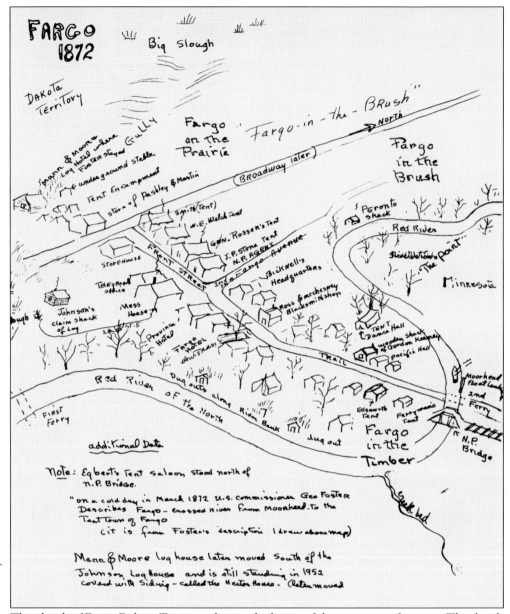

This sketch of Fargo, Dakota Territory, depicts the layout of the town in its first year. The sketch illustrates the marshes in the surrounding land and the river bends that made flooding a constant threat to the growth of these two market communities. (NMHC.)

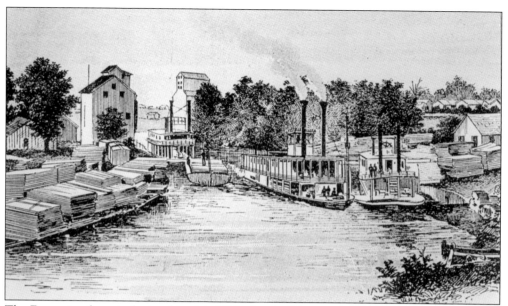

The Fargo riverfront is depicted in this 1870s sketch. Thousands of tons of grain, lumber, and manufactured goods would pass through here, the largest market center in the region. Many Fargo merchants made fortunes on the early river trade. (NMHC.)

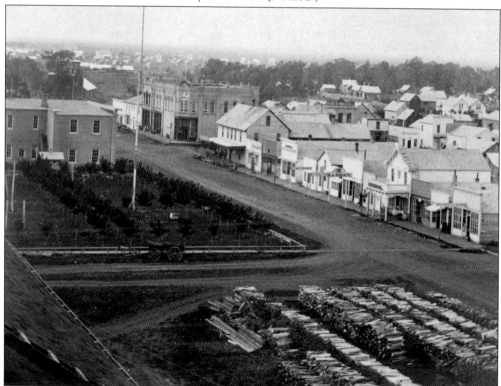

This is Moorhead in the 1880s. In addition to being a market town, it was the seat of Clay County, Minnesota, and benefitted from the liquor trade that grew quickly after Dakota citizens voted to make theirs a dry territory. (NMHC.)

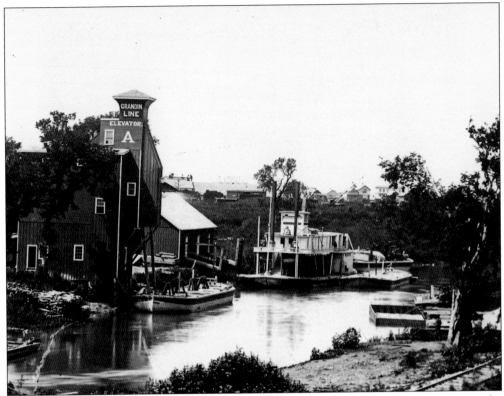

This early image reveals the river's narrow features. Riverboats had to be small to navigate the tight turns. The Red River's geography made flooding inevitable when rain and snow levels overwhelmed the low levies that both towns first constructed. (NMHC.)

Settlers of the valley regarded themselves as hardy folk, able to adapt to the region's harsh climate. They farmed the land, fashioned new communities, and built new lives. (NMHC.)

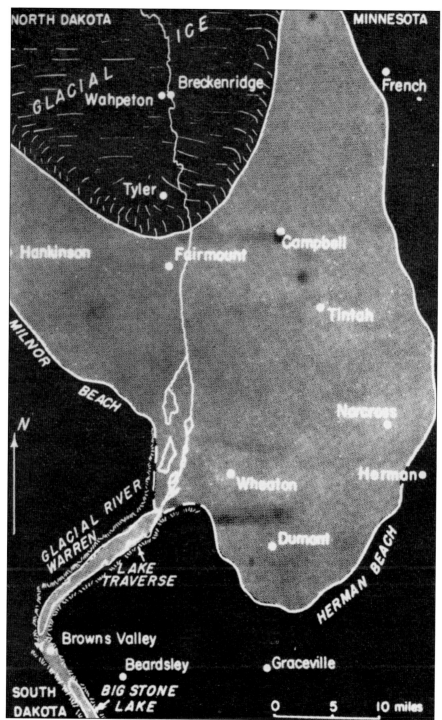

The Red River was formed when the massive glacial Lake Agassiz receded about 9,000 years ago. The river emerged slowly, pushing northward toward Lake Winnipeg. The river's valley (seen at the top in this early map) is quite narrow and lower than sea level. The floodplain proper is essentially the flattened remains of the glacial lake bed. (NMHC.)

All moisture that falls on the floodplain drains into the Red River system. Average annual rainfall on the plain is 35 to 40 inches, while snowfall can vary. The snow will melt at unpredictable rates, but prospects for major floods, concluded one study of the region, are "well above average." (NMHC.)

Lake Traverse, situated some 90 miles south of Fargo-Moorhead, is where the Red River originates. An earthen dam constructed by the US Army Corps of Engineers in the 1930s regulates the level of the lake. Water from here flows north and merges with the Otter Tail River at Breckenridge, Minnesota, where the Red River formally begins. (Author's collection.)

Telephones were being widely used by the 1880s, but most rural residents along the river relied on local newspapers like the *Moorhead Citizen*. The paper's office is seen here. News of rising water often spread by word of mouth. (NMHC.)

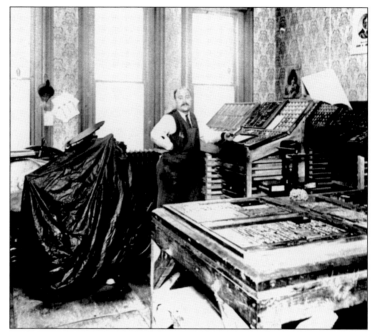

The Red River runs through Fargo and Moorhead, reaching a small falls where ice can cause the water to back up and pool. Measurements of the river's flow (cubic feet of water, passing per second: cfs) have been kept since 1901. In high flood situations, flow rate can rise to 9000 cfs. (Author's collection.)

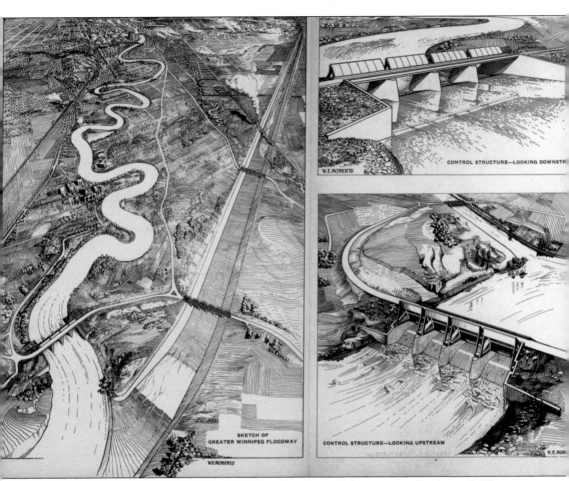

All communities along the Red River face emergencies. After a major flood struck Winnipeg, Canada, in 1950, the Canadian government constructed an elaborate floodway system of ditches and canals to channel water around the city. Similar proposals have been made for protecting Fargo and Moorhead. (Canadian Water Resources Division, *Report on Investigations into Measures for the Reduction of the Flood Hazard in the Greater Winnipeg Area*, courtesy NMHC.)

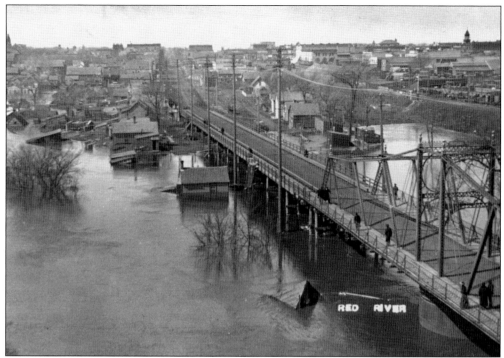

Human costs of flooding often outweigh economic loses. This image from the 1907 flood reveals various buildings, torn from their foundations, that were carried by the current until coming to rest. (HCSCC.)

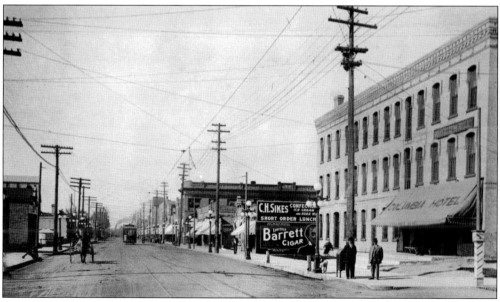

This is Moorhead's Front Street around 1915. The need to protect city electric and telephone services from floods became paramount. Sandbags were still a poor choice for protecting streets or buildings. Canvas bags could not stop slow seeping water. (NMHC.)

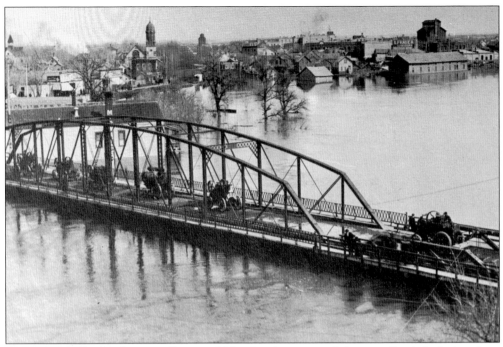

Protecting the bridges between Fargo and Moorhead was crucial during a flood, for losing them would devastate the economic wellbeing of the entire region. (HCSCC.)

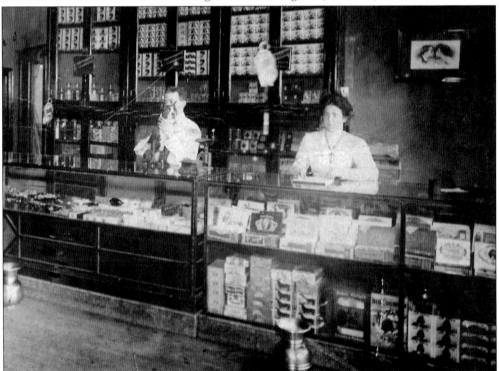

This is a photograph of an early shop in Moorhead. Goods had to be moved quickly when flooding threatened and then returned after floors and walls were repaired. (NMHC.)

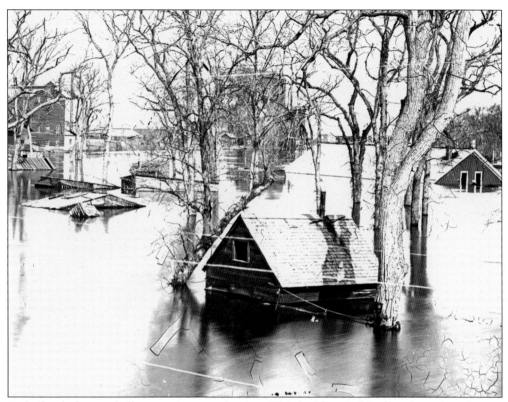

Early floods damaged all properties near the river. This building in Moorhead may have been a home, but appears more likely to have been a small barn or storage building. (NMHC.)

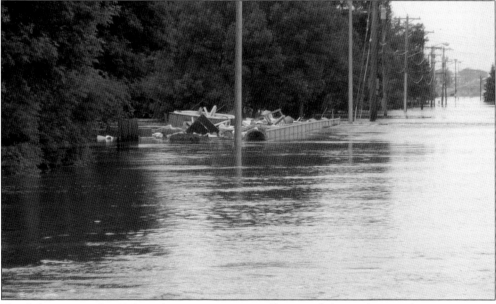

Flood damage in the 20th and 21st centuries usually extends beyond water damage. In 2011, chemicals and other toxic substances damaged the soil, impaired water supplies, and threatened the power systems. (US Army Corps of Engineers.)

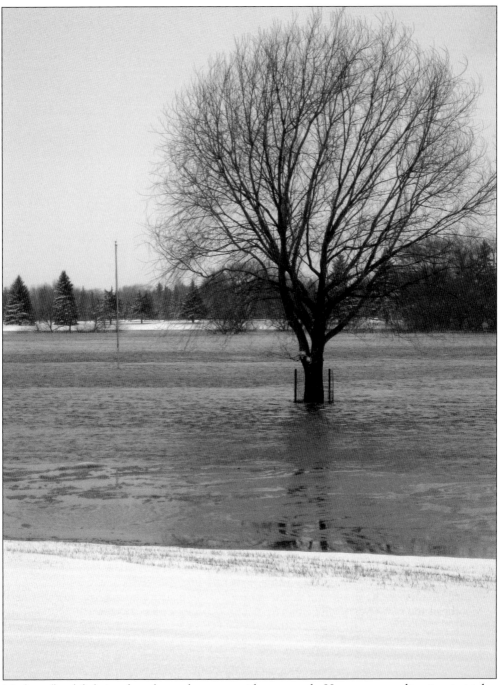

Modern flood fighting fares best when met with teamwork. However, coordination is tricky, especially as days pass before the water recedes and flood fighters become exhausted. The long-haul battle becomes the story of each new flood. (NMHC.)

# *Four*

# WARTIME FLOODING

Ole Jacobson was a tired man when he spoke to a reporter of Fargo's *Forum* newspaper the evening of April 3, 1943. As St. John's Hospital's chief of maintenance, he was manning the pump that kept the hospital's basement and power from being completely flooded. "We're pumping water out of the basements as fast as we can," he told the writer. "But if we get 18 more inches of water, which will bring the river up to the top of the pump's discharge. I don't see how we can do it then, but we'll keep trying."

The Red River flood of 1943 was one of the worst floods for the residents of Fargo and Moorhead. The river rose to a height of 34.3 feet, just about double the "minor flooding" level. By the time the crest occurred, on April 7, several hundred houses and businesses had been severely damaged, and many residents had been forced to evacuate. Engineers at Lake Traverse, south of the cities, had used the dam system there to "hold back a huge quantity of water" that might have washed away most of the towns. The improved dike protection, some of it paid for by federal funds in the 1930s, had prevented even worse damage. Even so, the mayors of both towns called for measures "to move buildings from the low areas where damage is the greatest."

Because the flood came when it did, nearly 18 months after the nation entered World War II, it seemed almost as if the rising river was a distraction from more frightening matters. The news in Moorhead and Fargo was dominated as much by war stories as flood stories, and soon after the water dropped again, reaching a 17-foot stage on April 15, people were focused once again on the battles in Europe and the Pacific.

But, as the images that follow show, the toll of the flood on those who lived then was a very heavy one.

A system of drainage ditches channeled rainwater to protect farmers' fields, but ice impeded many of these ditches. County inspectors worked hard to measure snow and clear ditches. In 1943, melting snow and rain combined to form a major flood. (HCSCC.)

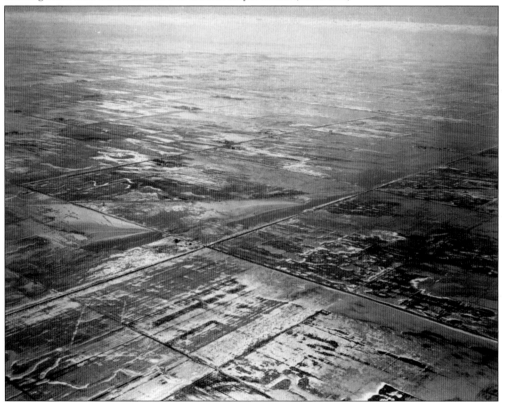

This aerial shot of the flooded countryside testifies to the mix of ice and water as flooding began. Many aerial photographs during this time were poor due to the vibrations of the aircraft. (HCSCC.)

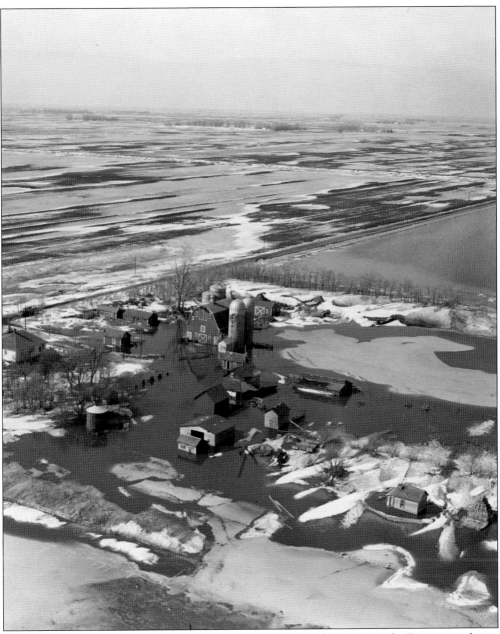

This aerial photograph shows the extent of water covering the countryside. Farms were being surrounded by water in April 1943. One farmer wrote, "Beavers, which I haven't seen for over 20 years, have taken up residence in my root cellar." (HCSCC.)

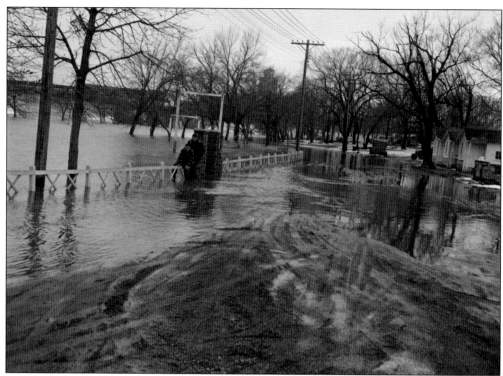

The Red River rose from 18 feet to almost 30 feet in a matter of days. By April 2, it stood at 28 feet, and the fear was that the river might reach 35 feet—a level that could flood most of both Fargo and Moorhead. (HCSCC.)

Each home near the river became a mix of flooded low ground and relatively dry high ground. No one could attempt to cross a yard or field without heavy boots. (HCSCC.)

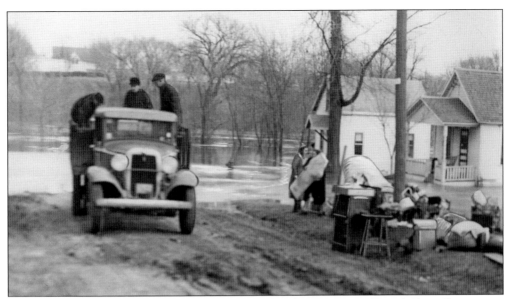

Evacuations began near the river. These two families' homes were in Fargo's Front Street area. By early April, over 200 people had fled their homes and evacuated to neighbors' houses or shelters. (HCSCC.)

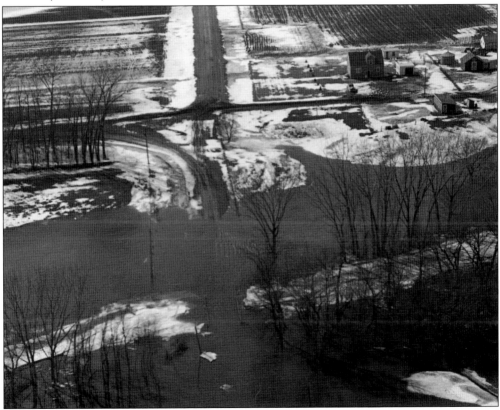

Washed-out bridges in the area hindered state assistance. Most bridges between Minnesota and North Dakota were under water for several days. (HCSCC.)

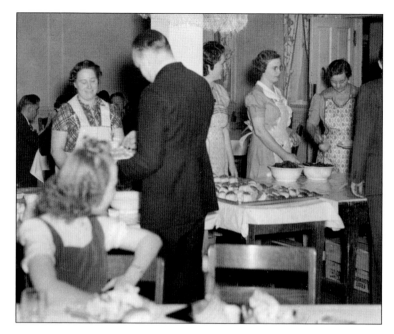

Many of the evacuees near Moorhead were fed at the Concordia College cafeteria with the American Red Cross providing provisions. It took a month before everyone could return to their damaged homes. (Concordia College Archives.)

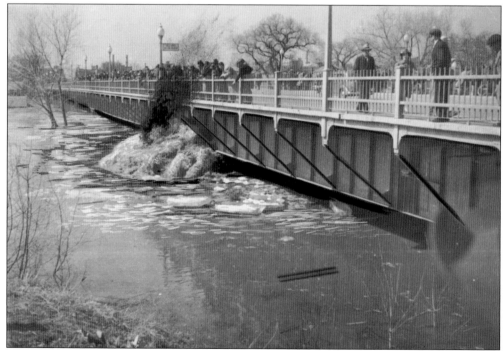

The "raging Red" carried broken tree limbs and anything else caught near the river and pushed them northward. Here, a loose bale of hay has jammed against the Main Avenue Bridge. Somehow, the straw was set on fire. The smoke has been darkened by a newspaper editor's pen. (HCSCC.)

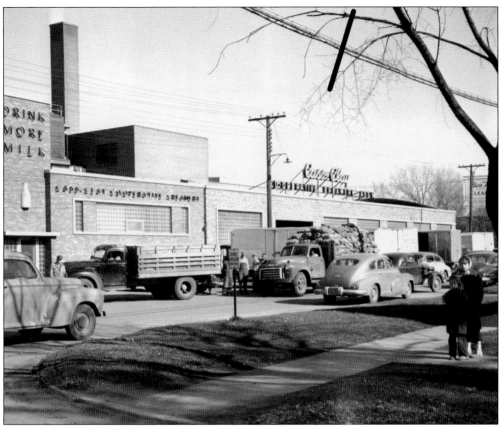

Cass-Clay Creamery was a major supplier of dairy products in the region and had contracts with the military during World War II. The 1943 flood overwhelmed the sewer system and filled the Cass-Clay plant with six inches of river water. Pumps kept the plant operating. (NMHC.)

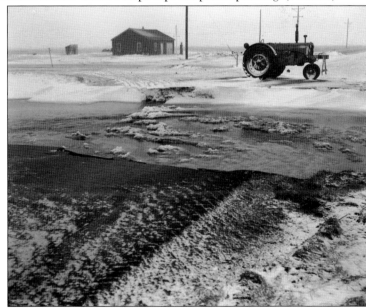

The water covered streets and roads and damaged vehicles that could not easily be replaced in wartime, as steel was earmarked for military production. (HCSCC.)

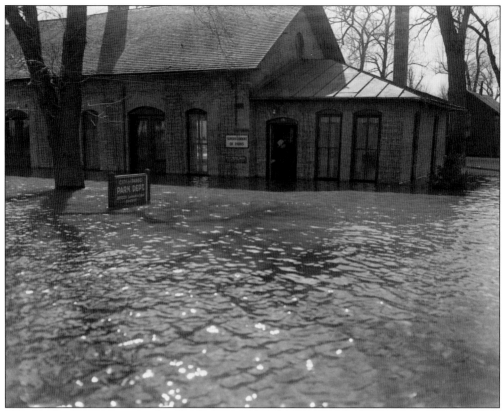

Town parks once again served as floodwater pools. The Fargo Parks department's main pavilion was inundated for over a week and required expensive repairs. (HCSCC.)

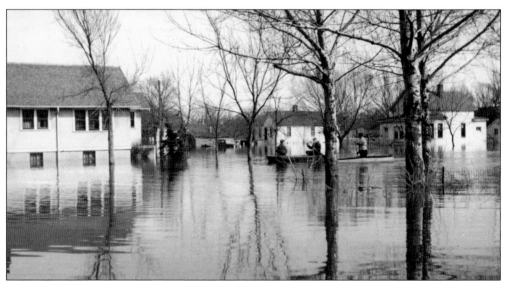

Flooded streets in low areas forced many to travel by boat. "Many basements of even the comparatively high ground business districts are likely to be flooded," reported the *Moorhead Daily News.* (Hagen family, NMHC.)

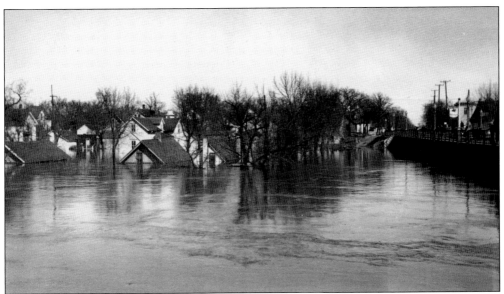
Several homes in north Fargo, along the west bank of the river, were virtually destroyed by the flood. Many were torn down after the water receded. (Hagen family, NMHC.)

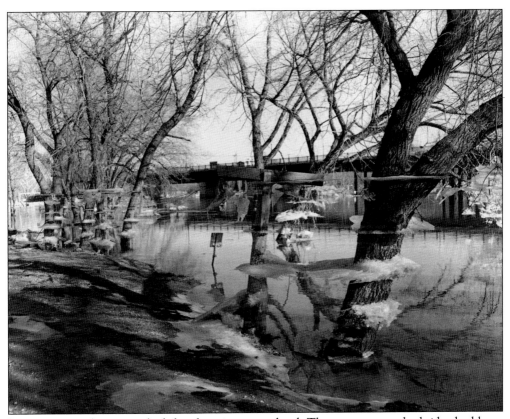
Ice rings around trees marked the changing water level. These trees near the bridge had been over a dozen yards away from the river before the flood occurred. (HCSCC.)

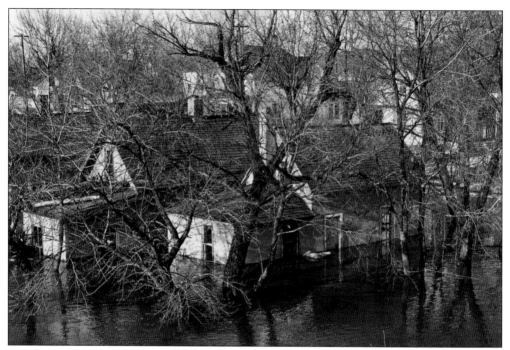

Residential damage was considerable. Although no full estimate of domestic property damage was published, losses were regarded as "considerably higher than in other floods" to that time. (Courtesy HCSCC.)

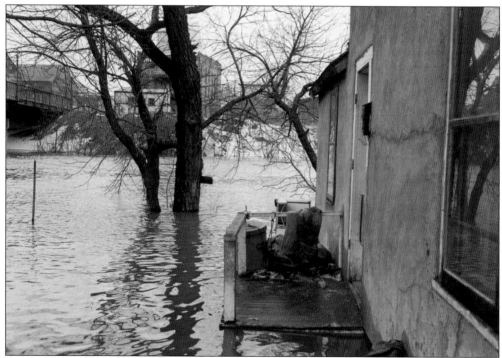

The margin between inconvenience and utter ruin was often very thin as the water slowly rose. Just a few inches more here and the ground floor is flooded. (HCSCC.)

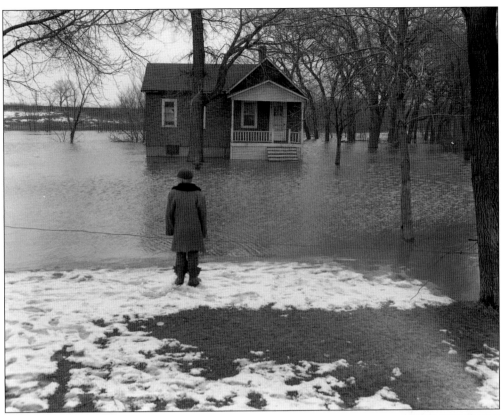

News photographers accompanied residents as they examined the homes they had evacuated. In this case, the basement of the home is likely flooded, but the ground floor may have remained relatively dry. (HCSCC.)

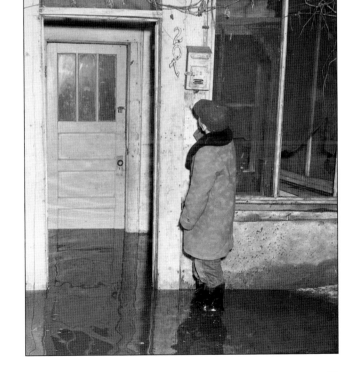

This house has taken water on the ground floor. Note the darker coloring on the exterior below the window, indicating the high-water mark. (HCSCC.)

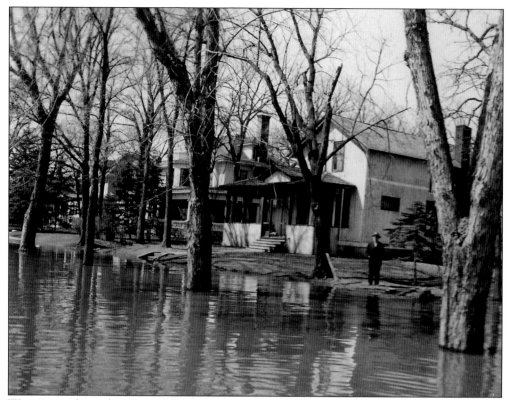

Warmer weather reduced ice, which helped greatly as the river level began to fall; however, it took days for many of the streets to reopen. Rebuilding streets was a large part of both cities' budgets for the next three years. (Red Cross, NMHC.)

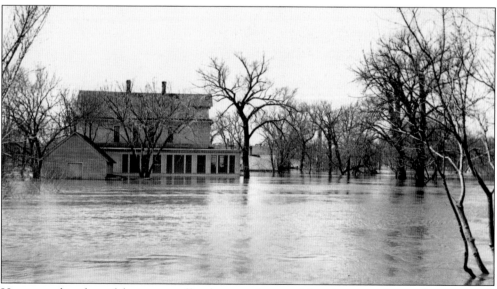

Homes on the edges of the towns suffered greater damage. Many homes with significant ground-floor damage had to be rebuilt on new foundations. (Hagen family, NMHC.)

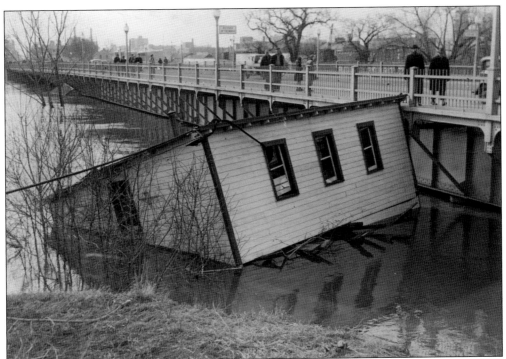

Some smaller buildings were swept up and sent downstream, where they either were wrecked or grounded near a bridge. (HCSCC.)

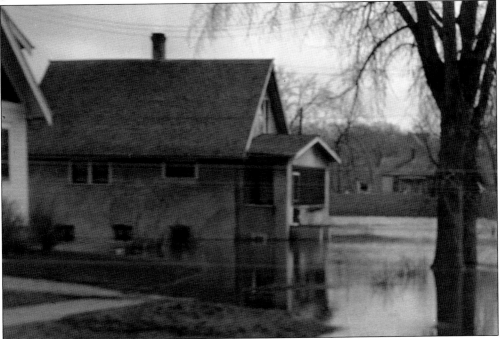

Contractors discussed the possibility of changing construction codes so that basements would not be built in future homes. The citizens objected to this, many hoping for larger postwar homes. The basement issue would be raised again after future floods. (HCSCC.)

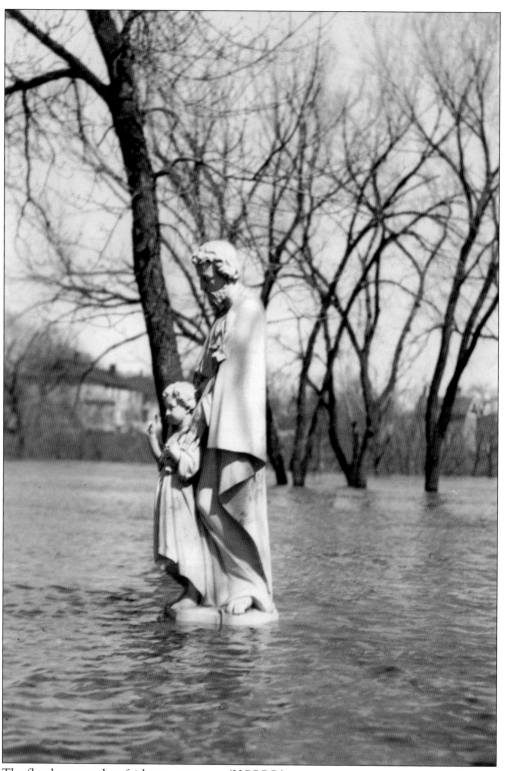

The flood respected no faith, no sanctuary. (HCSCC.)

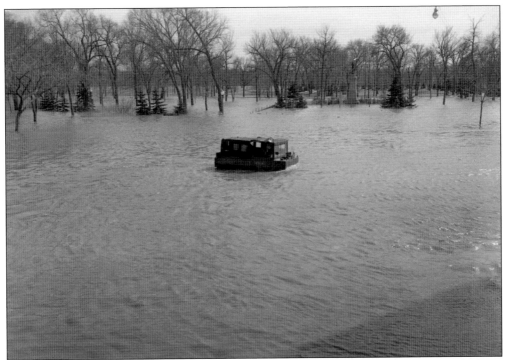

This water taxi was used during the height of the flood, making several trips a day. It looks to have been hurriedly constructed. (HCSCC.)

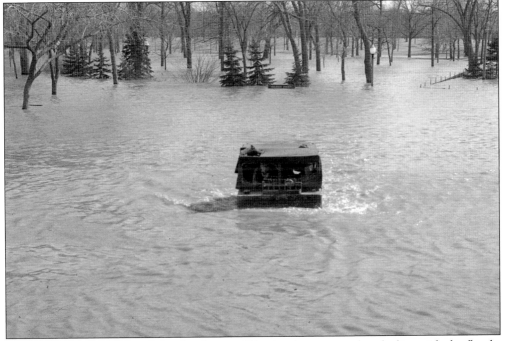

As one longtime resident of Moorhead put it, "You just became used to dealing with the floods, allowing more time to get things done, moving things out the cellar, whatever you needed to do to get by." (HCSCC.)

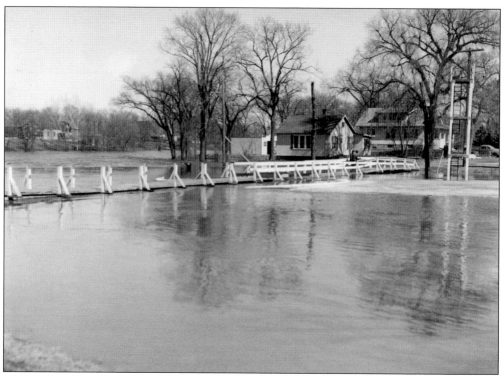

Makeshift walking bridges were constructed during the flood. This bridge was placed across the narrow section from Fargo to a popular Moorhead spot, Dommer's boathouse. (HCSCC.)

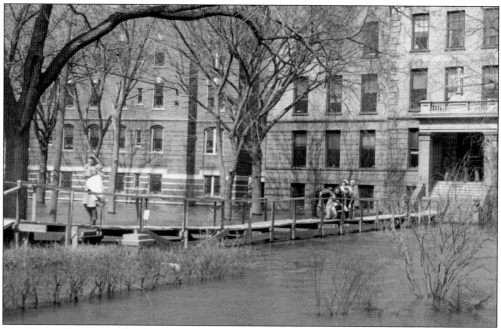

Another walkway was built at St. John's Hospital, located close to the river in Fargo. Many patients were released to home care or transferred to St. Luke's Hospital. Patients with dangerous conditions were kept at St. John's on upper floors. (HCSCC.)

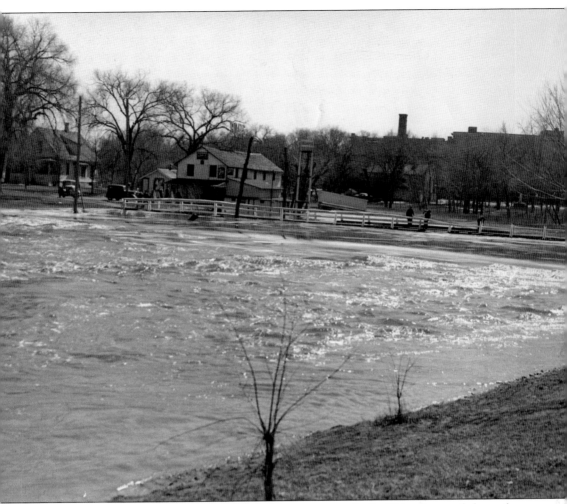

By the second week of April, the waters were slowly returning to the Red River's normal channels. The return to white water at shallow sections, such as the one here, was a good sign that the emergency was nearly over. Careful monitoring, and fears of rain, continued throughout the month. By then, both cities agreed that flood damage was enormous. (HCSCC.)

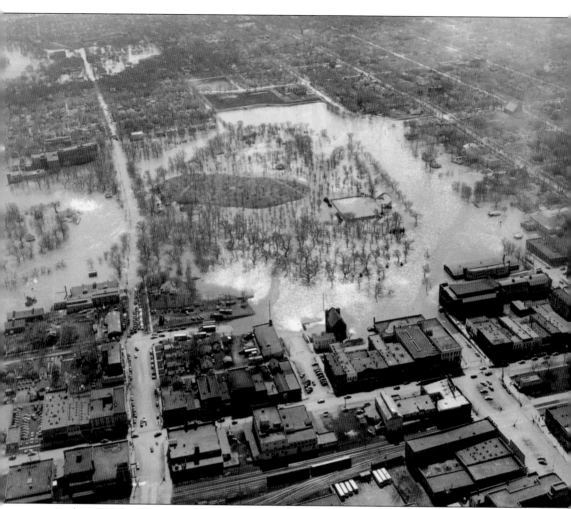

As this 1943 shot illustrates, the flood forced Fargo and Moorhead to protect their infrastructure. Both city governments hoped that once the war ended, new funds for dikes and new methods for holding back water could be used to limit the ravages for future flooding. "It is inevitable," Moorhead's mayor predicted, "that the river will rise this high again." It took weeks for normal river conditions to emerge. (HCSCC.)

# Five

# TAKING PREVENTIVE
# MEASURES

Throughout the first 80 years of their joint history, Moorhead and Fargo had dealt with floods pretty much with their own resources; both states granted what aid they could, and voluntary organizations like the Red Cross provided additional assistance. That pattern changed after World War II ended in 1945. The war, for all its destruction and sadness, had ended with the United States emerging as a super power nation. It was also the wealthiest nation in the world. Between 1945 and 1951, the US Gross Domestic Product almost doubled. The national government had money to give to the states for improvements and did so, with highway acts, river and harbor improvement bills, and in 1950 the Disaster Relief Act that permitted the Federal Emergency Management Agency (FEMA) to help deal with such things as floods with aid "in the form of equipment, supplies, facilities, personnel and other resources." Millions of dollars became available to Moorhead and Fargo, not only to clean up after floods, but to do something to guard against them.

In the 1950s, much of the Red River's riverfront, built decades before to promote a river commerce that was now almost nonexistent, was filled with levies to hold back rising water. It took more than a decade to construct these, and there were problems before the work was completed. The 1950 flood spared the Fargo-Moorhead area great damage, but the heavy, wet snow northwards did greater damage to towns like Grand Forks and devastated Winnipeg, where over 100,000 people were evacuated.

It was the 1952 flood that hit Fargo and Moorhead hard.

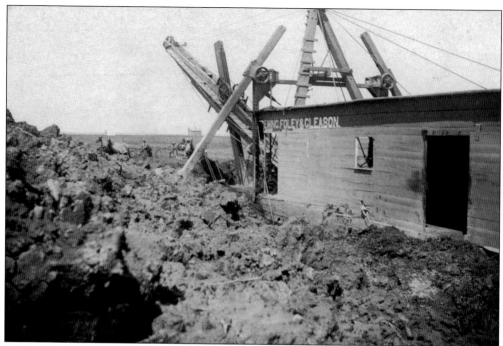

One traditional method used to try and control flooding was the increased use of drainage ditches. Here, a crane is constructing a long ditch to channel water into the river. (HCSCC.)

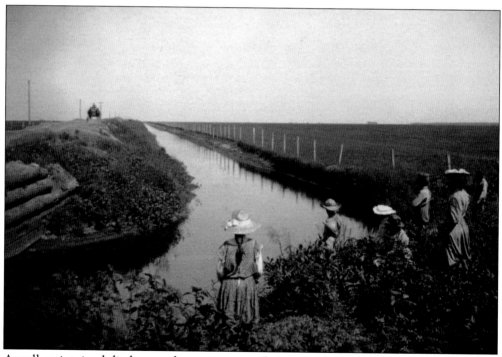

A well-maintained ditch moved water at a steady pace and might reduce sudden flooding from rains or snowmelts. This ditch near Georgetown was maintained by the Minnesota state government. (HCSCC.)

The Red River is not particularly deep, but its current can be treacherous. After five Fargo-Moorhead children drowned in 1944–1945, both cities lined the river with signs reminding swimmers to be careful. This 1949 image records the recovery of a drowned child. (HCSCC.)

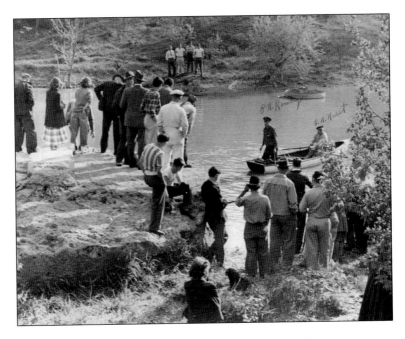

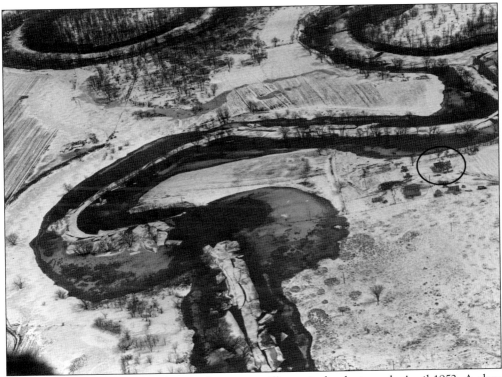

Snow was still melting when the river began to spill over its banks in early April 1952. A clear aerial image shows the narrow river channel threatening farms. (HCSCC.)

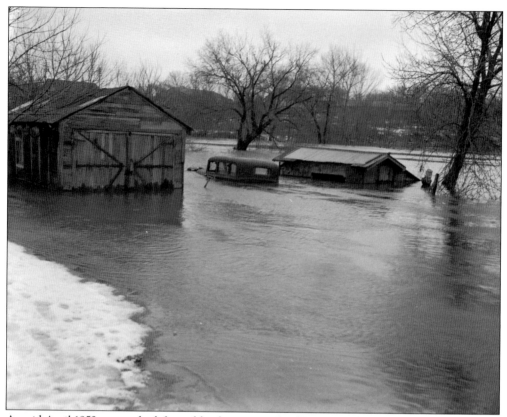

As mid-April 1952 approached, farms like this one south of Fargo were being flooded. The National Weather Service, after observing the Red's rate of rise, warned that the flood this year could "be higher than that of 1943." (HCSCC.)

This wire gauge, installed on one of the Fargo-Moorhead bridges in 1932, could measure depth changes and water speed and was used to project when the high water might arrive. (HCSCC.)

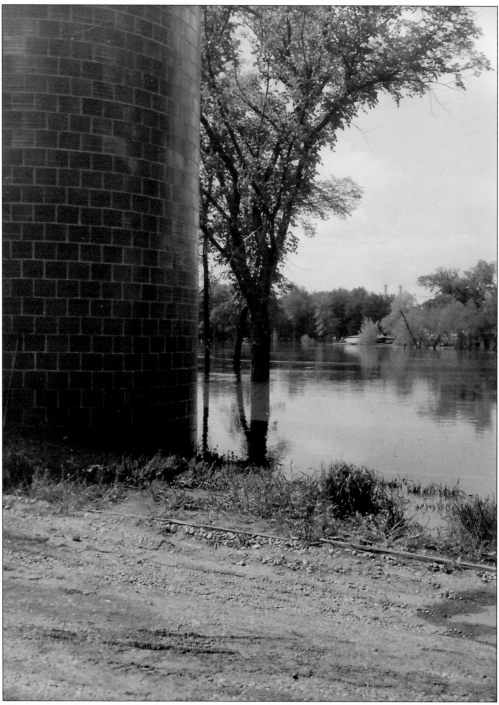

The cities used more solid brick structures to protect facilities. This silo-like structure held supplies and gasoline for one of the hospitals. (Red Cross, NMHC.)

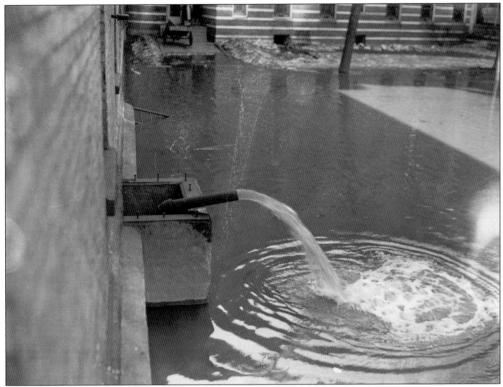

Pumps for homes were in greater use. This pump is likely one that operated with a gasoline motor. It would have required the homeowner to monitor it carefully, especially to prevent fires. (HCSCC.)

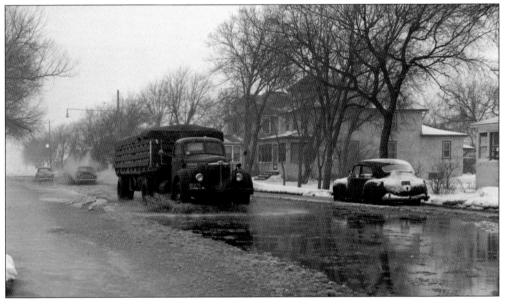

Floodwaters filled the streets of both cities, even as snow remained on the curbs. "Many basements of even the comparatively high ground business districts are likely to be flooded," reported the *Moorhead Daily News*. (HCSCC.)

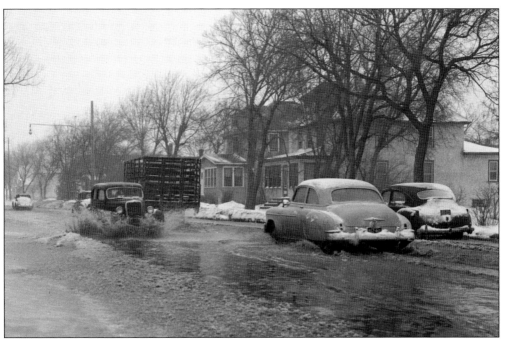

Newspapers noted that water damage to cars and trucks was widespread. Auto bodies rusted, and brake systems and undercarriages were often ruined. (HCSCC.)

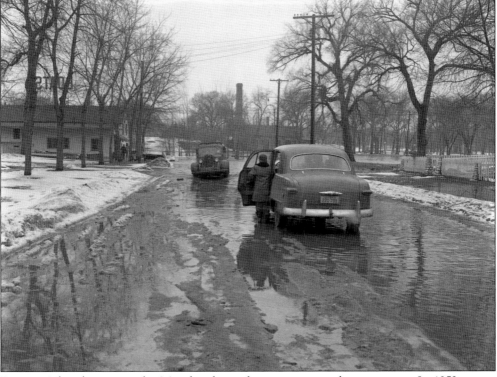

Dommer's boathouse, on the Moorhead riverfront, was a popular attraction. In 1952, it was damaged, and the road leading to it (pictured) was awash for about six days. (HCSCC.)

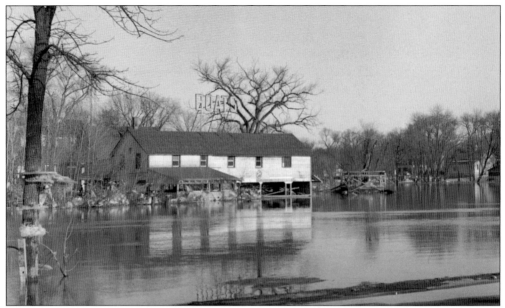

Dommer's had water still covering the ground floor when this shot was taken. As in previous floods, rings of ice can still be seen clinging to trees. (HCSCC.)

In this street scene, an ice ring marks the high-water level. Clearly, the entire street had been under about four feet of water. Note the shadow of the photographer. (HCSCC.)

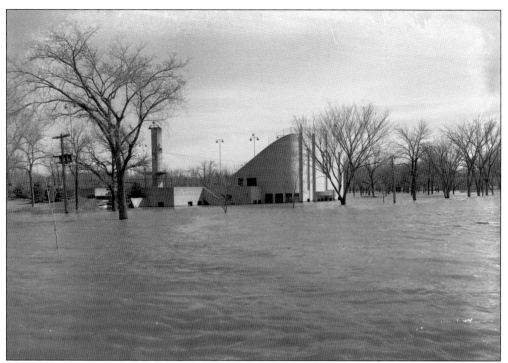

Island Park's bandstand received minor damage from the floodwaters. The water flowed past the park and into Fargo's downtown area. (HCSCC.)

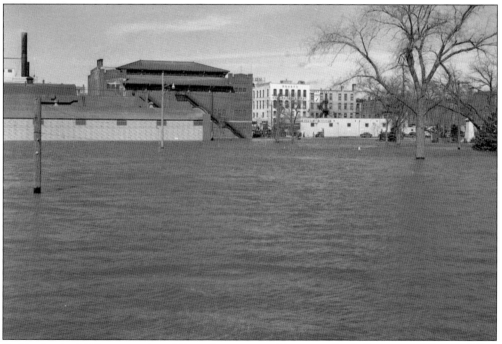

Suddenly, the Midwestern city of Fargo bore a resemblance to the Italian city of Venice. "This flood will do untold damage to the businesses of our town and to the state as a whole," reported a local radio newscast. (HCSCC.)

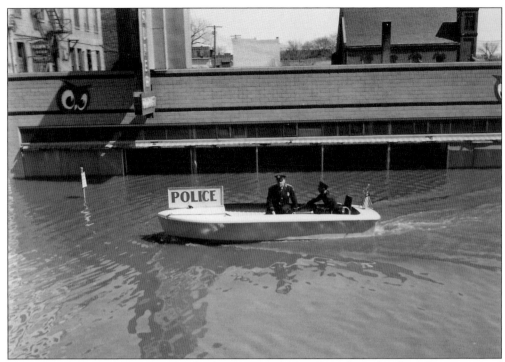

The worst damage in Fargo was the flooding on Broadway, where about five feet of water covered the street. Fargo's police relied on boats to reach people in danger. (Red Cross, NMHC.)

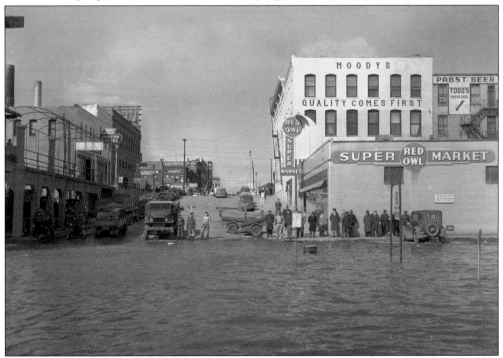

On Broadway, the Red Owl Grocery was damaged. National Guard trucks, in the left background, were used to help evacuate residents from apartments on the upper floors. (HCSCC.)

A photographer shot this interior of Red Owl's meat department. The "Strictly Fresh" sign on the wall provided a certain irony to the moment. (Institute for Regional Studies, North Dakota State University.)

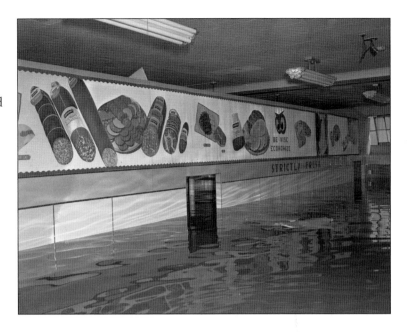

Household damage is clearly documented in this post-flood Red Cross photograph. Many people reused wood furniture after drying it out, but upholstered furniture was generally ruined. (Red Cross, NMHC.)

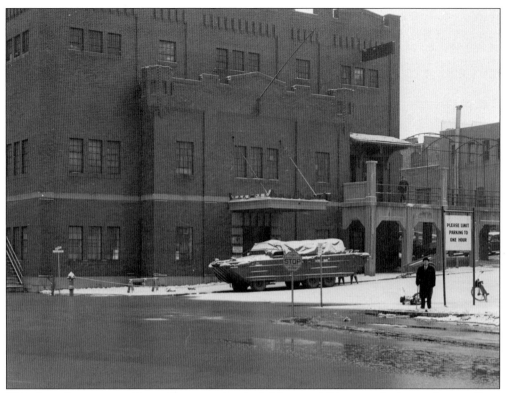

This time, the water taxi is a military surplus dual-drive amphibious truck. As can be seen from the photograph, these boats were tightly packed. (HCSCC.)

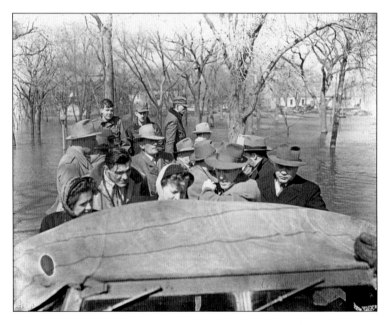

Businesses suffered lost revenue as families found it hard to move about. Post-flood repairs aided hardware, lumber, and other such shops, but other retailers lost substantial money. (HCSCC.)

Once again, St. John's Hospital was on the front line. And, again, while some patients went home, critical patients were moved upstairs. (Red Cross, NMHC.)

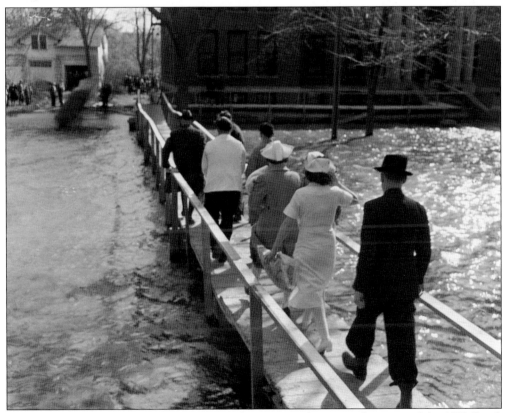

Another walkway provided entry in to St. John's Hospital. During the worst of the 1952 flood, ambulances were damaged when water seeped into the hospital's garage. (HCSCC.)

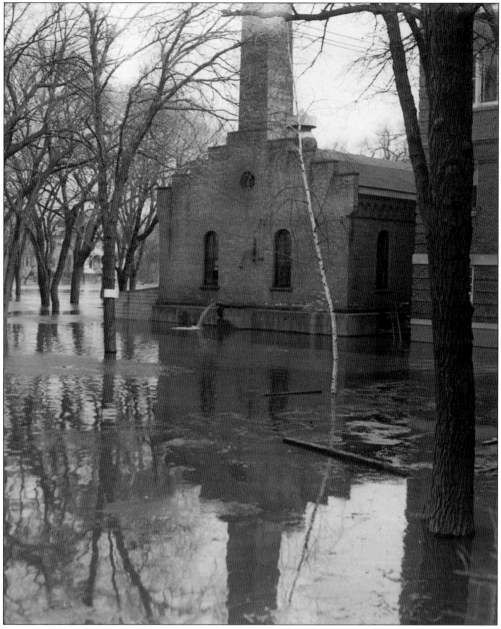

Major public buildings were heated and powered by machinery that was often housed in separate buildings. This powerhouse had to be manned around the clock to prevent the flooding from interfering with power and heat. Note the pump operating near the entrance. Canvas sandbags could only reduce the seepage. (HCSCC.)

By the third week in April, the river crested at 28.79 feet, slightly higher than the 1943 crest. As the water dropped, scoured ground was left where spring grass had just begun to grow. (Red Cross, NMHC.)

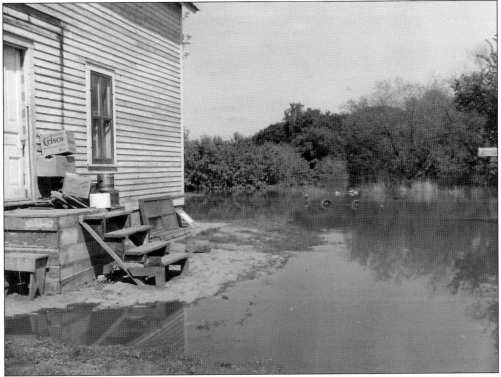

The receding water would not return to normal levels for several days. Many families lived in wet homes. At that time, limited information had been compiled about a flood's impact on health. (Red Cross, NMHC.)

After 1952, floods did less damage until the late 1960s. The respite allowed Moorhead and Fargo to purchase properties near the river and demolish the buildings. (HCSCC.)

Construction of high levies continued each spring and summer. (HCSCC.)

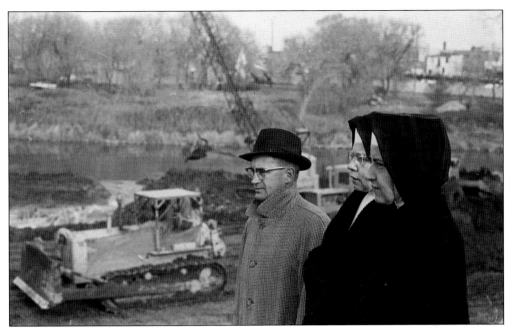

In Fargo, city officials purchased a small convent near the river in order to complete its dike plan. The city relocated the nuns onto other property, away from the river. (HCSCC.)

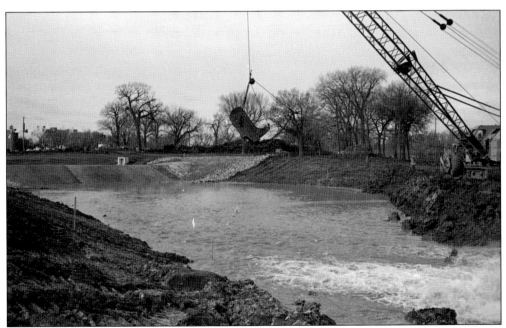

Raising the riverbanks required heavy machinery to dredge the river bottom, lay rocks for dike foundations, slope the dikes, and top them. Many of the contractors doing the heaviest work were advised by the Army Corps of Engineers. (HCSCC.)

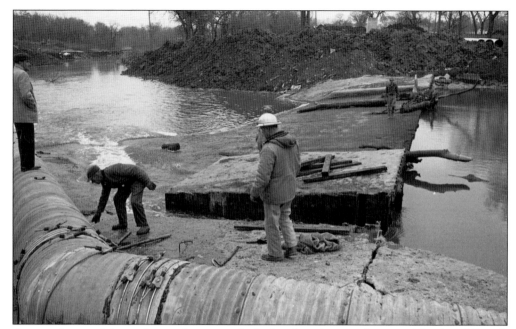

A central part of the work was the removal of a bend in the river between Third and Fourth Streets in Moorhead—a frequent spot for major flooding. By pumping water into a holding pond, engineers and workers constructed concrete sluices to create a more placid flow. (HCSCC.)

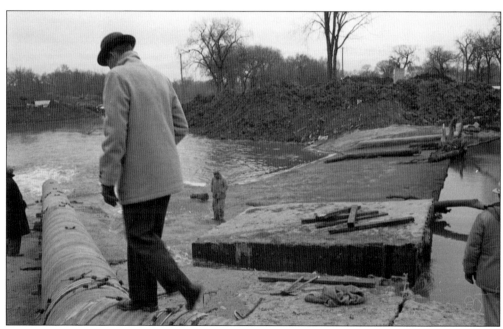

Over 400,000 cubic yards of earth were excavated in order to re-channel the river and build cutoff channels that could "reduce flood heights by about one foot immediately upstream." (HCSCC.)

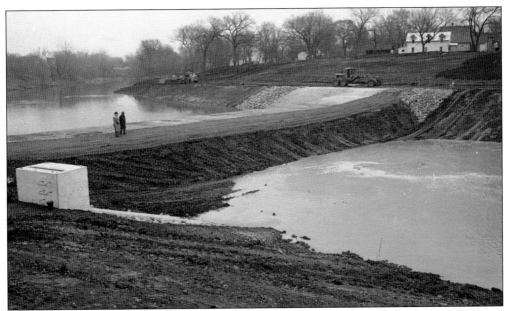

Cutoff channels were constructed by using temporary dirt dams to isolate water, clean out the obstructions, pour concrete, and install pumps for the channel. This one is being built during the last warm days of 1959. (HCSCC.)

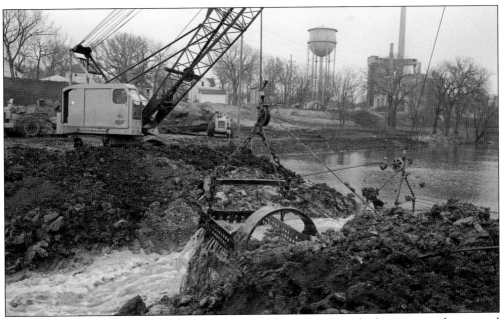

Once cutoff work was complete, the temporary dikes were breached to restore the normal channel. (HCSCC.)

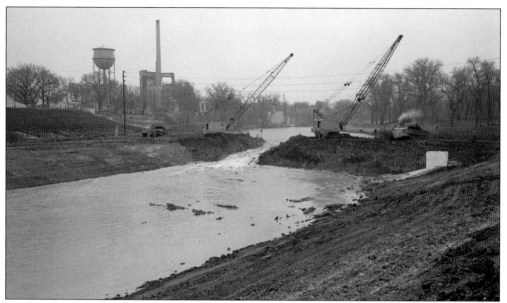

The large levees on each side of the Red River took shape. This levee required over 200,000 cubic yards of gravel and concrete, with a pumping capacity of 45,000 gallons per minute. (HCSCC.)

Construction of the levee involved raising the riverbanks south of the Main Avenue Bridge by some 12 feet. Once again, properties were demolished. (HCSCC.)

Hundreds of trees were removed in order to carry out the levee construction. Some protested this, but the need for protection overrode concerns. (HCSCC.)

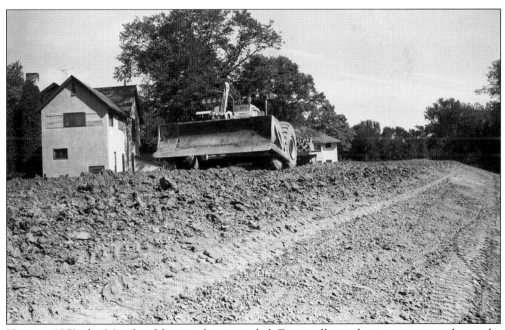

Here, in 1959, the Moorhead levee is being graded. Eventually, as the city grew, new homes by the river were built, sometimes unwisely. (HCSCC.)

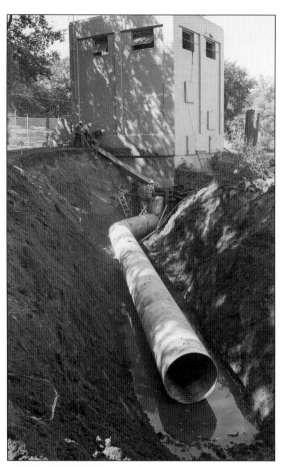

This pump station was installed at the Fargo levee in order to feed snowmelt and rain into the river. Over 1,000 drain sewers and an equal number of new storm sewers were constructed as part of this project. (HCSCC.)

At "the falls," where the river falls four feet, water was diverted while a concrete apron was installed. This reduced the longtime problem of brush gathering at the falls and creating obstructions during high water. (HCSCC.)

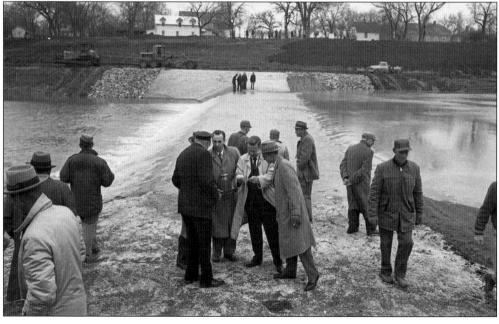

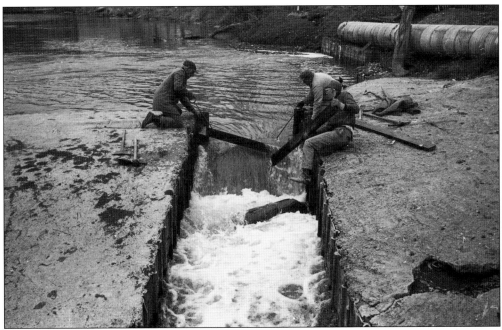

A temporary diversion was cut open after the falls construction was completed. (HCSCC.)

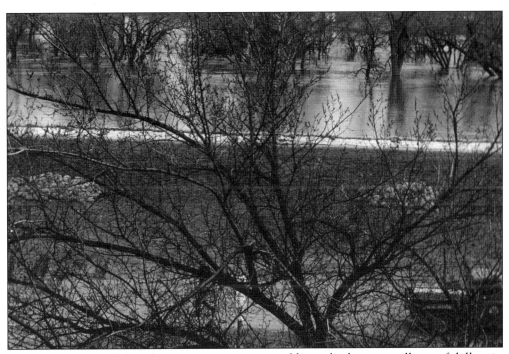

Engineers estimated that the new construction would save both cities millions of dollars in damages. Dry weather kept that estimate untested until 1969, when heavy rains pushed the river to a 37.7-foot crest, obligating Fargo and Moorhead to build some temporary dikes. (Institute for Regional Studies, NDSU.)

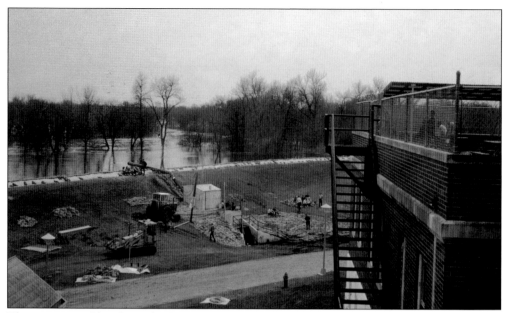

The temporary dike along Elm Street in Fargo prevented the flooding of the Veterans Hospital, seen on the right. (Institute for Regional Studies, NDSU.)

For most of the 1970s and 1980s, the Red River was quite low, with drought conditions from 1987 through 1990 bringing the water to its lowest levels since the 1930s. Floods seemed, for the moment, like a problem that had been solved. (HCSCC.)

*Six*

# THE 1997 DELUGE

The 1997 flood of the Red River crested in the Fargo-Moorhead area at 39.64 feet, higher than even that of the 1897 flood. As a result, people in the cities referred to it as the "flood of the century" during those early weeks of April. Later, they called it the "500 Year Flood," pointing to data calculations from the National Weather Service that suggested only a .002 percent chance that major water factors (saturated ground from the wet summer, high water content in the heavy snows, and fast melt runoff mixed with rain) would converge in such a manner.

While it was true that the melt, rain, and heavy snows combined into something like a "perfect storm," there were other factors that contributed to this most serious flood to date. Farmers now drained their land more quickly, using pumps to pour water into the drainage ditches at a much faster rate. Added to these changes in water management were changing demographics; the population of Moorhead and Fargo had grown considerably since the 1960s, and many of the new homes (with their expanded water use and sewer systems) were much closer to the river.

The result was that at the beginning of April, water levels in the rivers and lakes rose at unprecedented rates. Once the snow thaw accelerated, emergency situations developed quickly. Almost all the counties of North Dakota and western Minnesota were severely damaged by flooding; housing damage came to tens of millions of dollars, and agricultural losses ran in the billions. In Fargo and Moorhead, neighborhoods near the Red River were in danger of being destroyed by the rising river, and neighborhoods on the edges of both cities were endangered by overland flooding. It took the combined efforts of all levels of government to prevent the ruin of both communities. Federal troops and state National Guard troops, guided by the US Army Corps of Engineers, constructed emergency dikes. Neighbors, aided by volunteers from schools and other communities, organized to sandbag homes. City services repeatedly responded with effective solutions to numerous emergencies.

In the end, the two cities survived the flood. But, as the images in this chapter show, it was a close call, and memories of the 1997 flood would continue to affect both communities as they planned for the future.

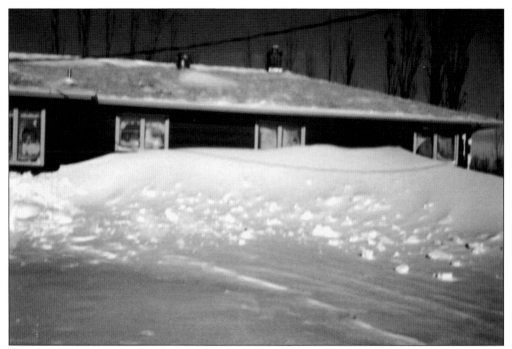

Record snowfalls in the winter of 1996–1997 made a flood inevitable that year. With an average of 117 inches of snow across the Fargo-Moorhead area, most homes looked like the Rassier family house, seen here in March 1997. (Courtesy Julie Rassier.)

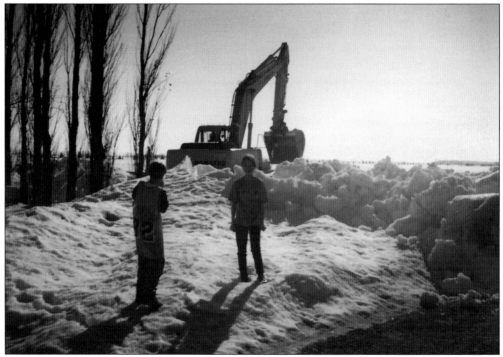

In an effort to prepare for the spring melt, city and county employees hauled trucks filled with snow away from several neighborhoods (Courtesy Julie Rassier.)

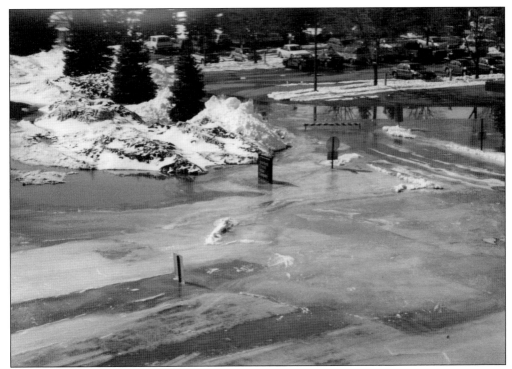

From April 4 to April 6, a final winter storm began with freezing rain and then dropped 10 to 20 inches of snow on the region. High winds brought down icy power lines, leaving 50,000 locals without power. The rivers began a fast rise. (NMHC.)

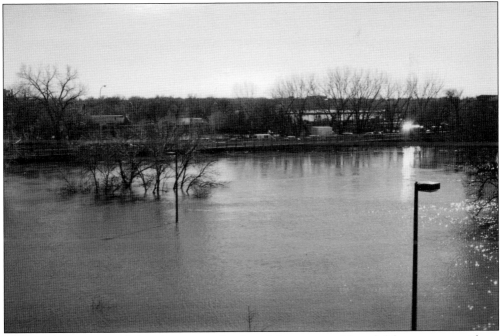

Melting, slushy snow added to the ensuing flood, and the power problems left homeowners without working sump pumps. Basements soon filled with water. (NMHC.)

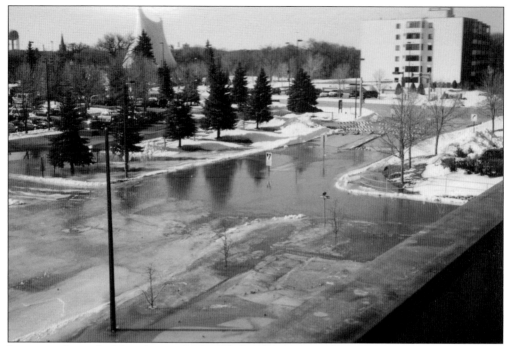

Low ground near the Main Avenue Bridge filled with water in early April. The Heritage-Hjemkomst Museum (upper left) was cut off before a dirt road was built. (NMHC.)

In southern Fargo, homes were endangered by overland flooding from melting snow and the nearby Sheyenne River. Calls went out for emergency sandbaggers. (NMHC.)

North of Moorhead's city limit, the unincorporated Oak Port neighborhood was nearly overwhelmed. The area was soon isolated as roads were closed. (NMHC.)

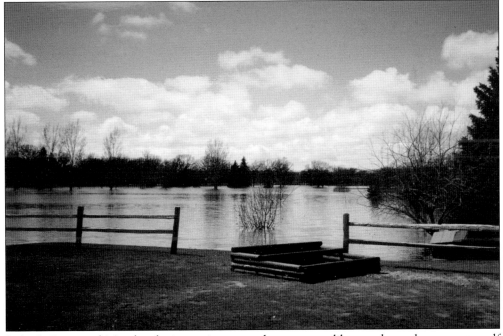

In both Fargo and Moorhead, city engineers used emergency dikes to channel water onto golf courses, using them as holding ponds. (NMHC.)

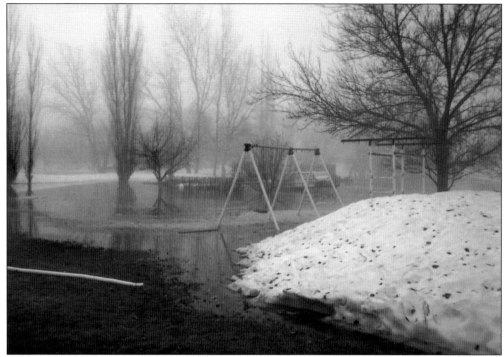

The Rassier home was threatened by the melting snow. Their backyard "looked like a water park," the Rassiers' daughter told a friend. Note the pump hose on the left, working full-time to protect the basement. (Courtesy Julie Rassier.)

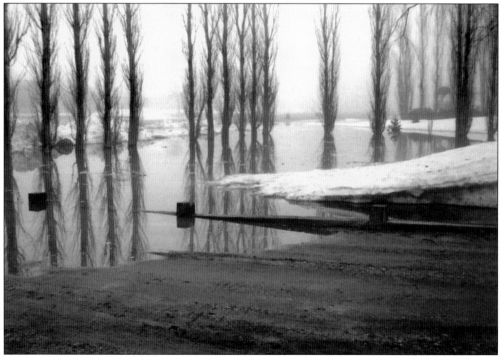

Here is the Rassiers' front driveway on April 4. (Courtesy Julie Rassier.)

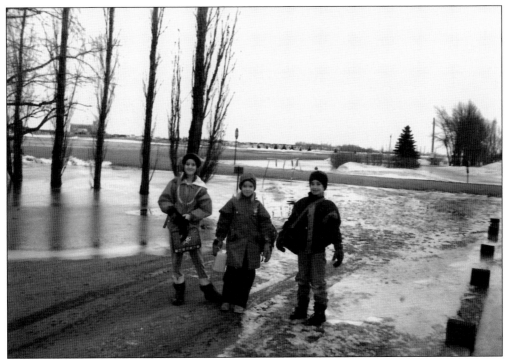

David and Julie Rassier's children used gumboots to walk from the drive to the bus stop, leaving the boots by a tree for the afternoon's return trip. (Courtesy Julie Rassier.)

In order to reduce the water pressure on the home's foundation, county engineers pumped water from the ditches into a large field on east side of road. (Courtesy Julie Rassier.)

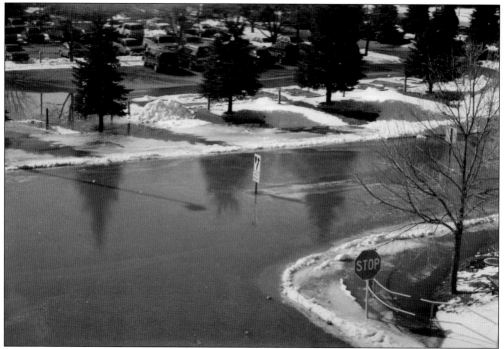

As streets filled, neighbors joined together to protect homes with sandbags and pumps. They found animals, including squirrels and rabbits, taking shelter in basements and garages. One woman saw a turtle swim from one dike to another, looking for refuge. (NMHC.)

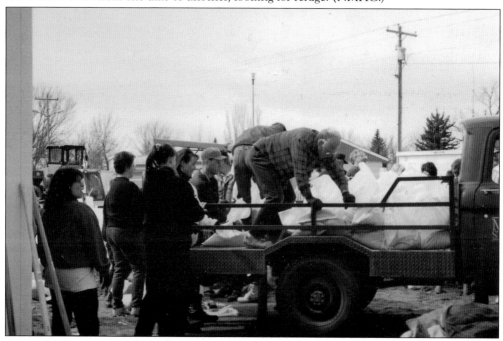

Area schools suspended classes as students formed sandbag teams. "The students saved a lot of our homes," the mayors of Fargo and Moorhead acknowledged after the emergency. (Minnesota State University, Moorhead.)

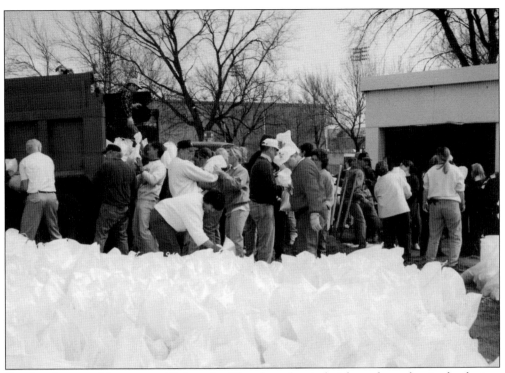

Sandbag lines could construct 30 feet of a dike, three feet in height and two feet in depth, in a couple hours. (Minnesota State University, Moorhead.)

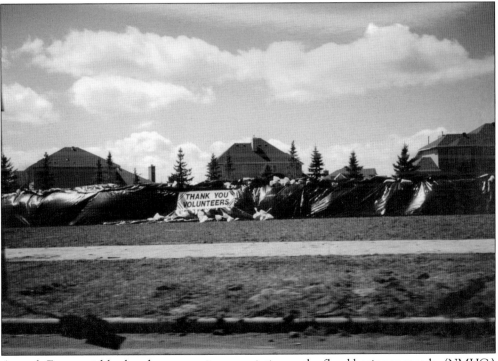

A south Fargo neighborhood expresses its appreciation as the flood begins to recede. (NMHC.)

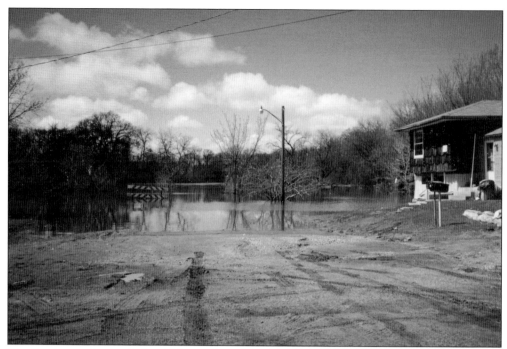

The flood crested at just below 40 feet in Fargo-Moorhead, but the water poured northward, forcing the evacuation of Grand Forks. Transportation throughout the region was severely disrupted, and the river system was filled with oil and other chemicals. (NMHC.)

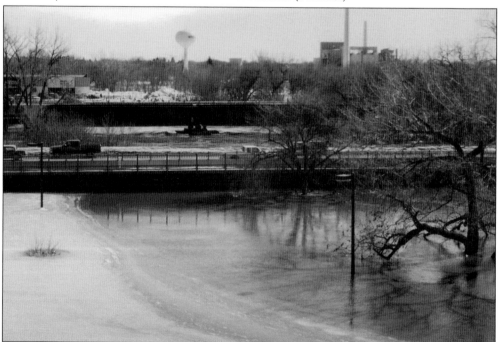

The Main Avenue Bridge and the railroad bridge (in background) were two of the very few that remained open, as they were vital for emergency personnel. Both cities agreed to build a higher Main Avenue Bridge after the flood. (HCSCC.)

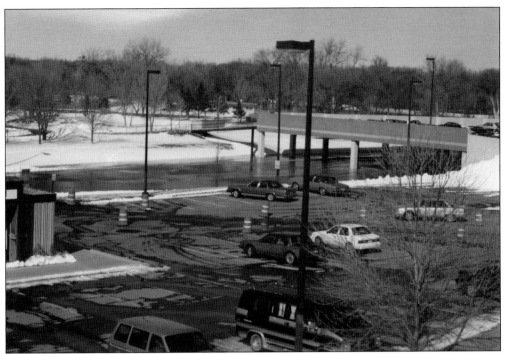

The two-tiered parking ramp at Center Mall in Moorhead was a favorite spot from which residents took photographs of the floodwaters and river. (NMHC.)

Temperatures were low during most of the flood, below freezing most nights. As a result, thin sheets of ice would form over flooded areas, creating transportation problems. Some families went sleepless for days in order to check pumps and dikes. (NMHC.)

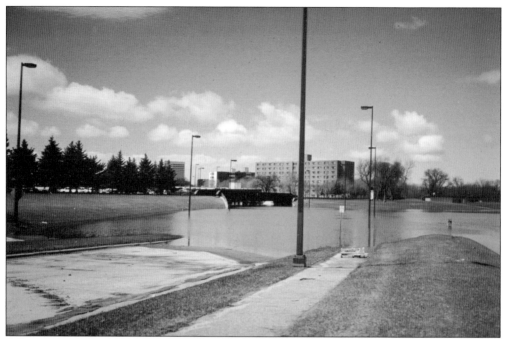

Inner-city transportation was snarled. Sewer systems and pump stations had to be monitored for weeks by city crews, National Guard troops, and FEMA volunteers. (NMHC.)

Power loss and the evacuation of Grand Forks forced hundreds to leave their homes. Moorhead State University converted its field house into a shelter and set up a message board system for reuniting families. (Minnesota State University, Moorhead.)

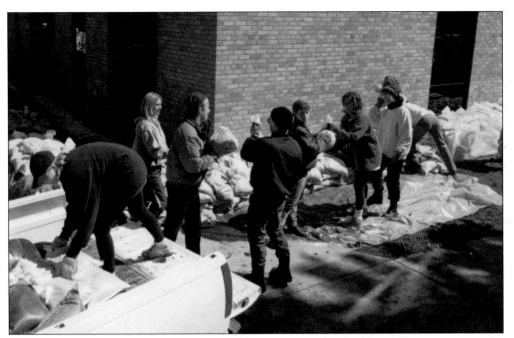

Concordia College in Moorhead had flood damage to one of its buildings. Even as repairs were made, Concordia's students helped others. The area's colleges suspended classes as students engaged in flood fighting. (Concordia College Archives.)

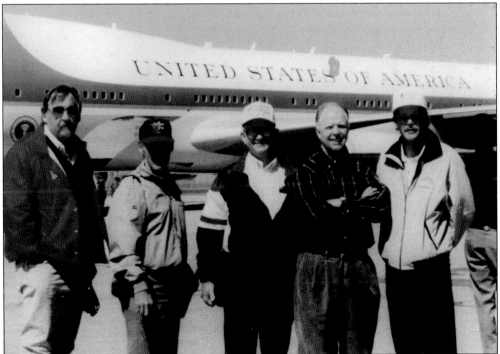

The flood having crested, Fargo mayor Bruce Furness (second from left) waited with city engineer Dennis Walaker (far left) and other officials to discuss flood damages with Pres. Bill Clinton on April 22, 1997. (Office of the Mayor, Fargo.)

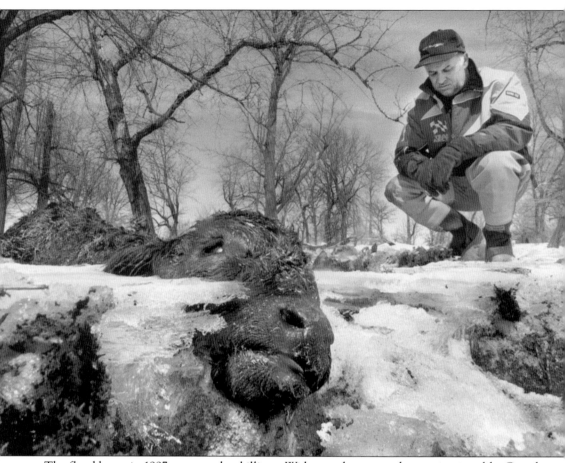

The flood losses in 1997 amounted to billions. Widespread property damage in cities like Grand Forks and Fargo were added to farmers who lost crops and livestock. This farmer lost almost all of his cows, which got caught in freezing waters. (Courtesy Ken and Wanda Visser.)

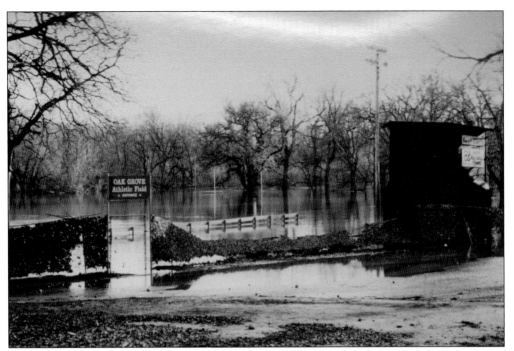

Oak Grove, a private high school in Fargo, was badly damaged when the flooded river swept through the campus the night of April 9. The school's inundated football field (pictured) was a lake for weeks. (Oak Grove Archives.)

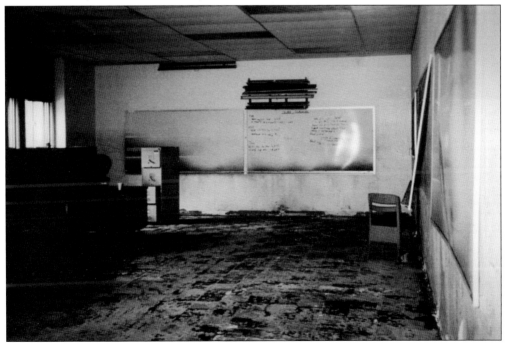

Several buildings were flooded on Oak Grove's campus. Classrooms in the lowest level of Jackson Hall had to be completely sanitized, rewired, repainted, and refurnished. The school's basketball court also had to be replaced. (Oak Grove Archives.)

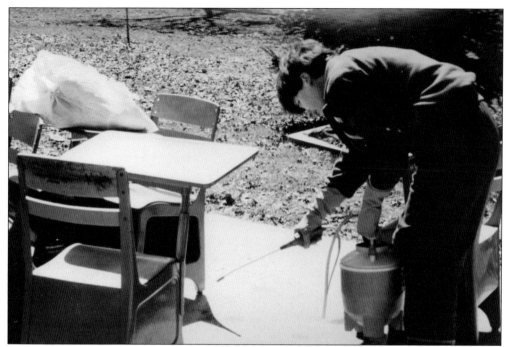

An Oak Grove volunteer uses disinfectant to sanitize desks that had been immersed in floodwaters. A major fundraiser helped the school reopen for classes in September 1997. (Oak Grove Archives.)

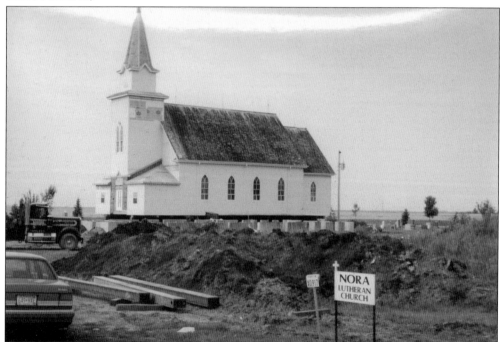

The Nora Lutheran Church had been the center of life in Gardner, just north of Fargo. The pressure of floodwaters from the Red River pushed the little church partially off its foundation in April 1997. (NMHC.)

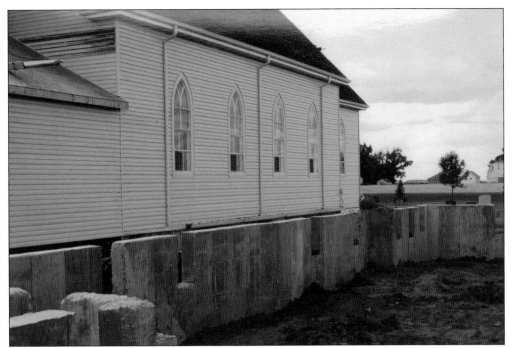

A restoration of the Nora Church was completed in the summer, aided by FEMA funds and private donations. Engineers used hydraulic jacks and timber to raise the church and place it on a new foundation on higher ground. (NMHC.)

Fargo and Moorhead city governments purchased damaged homes near the river and demolished them. A wild turkey (at center in the image) inspects the site where a house once stood. In the background, work crews continue removing the scrap of other homes. Higher, broader, permanent dikes replaced the former neighborhood. (NMHC.)

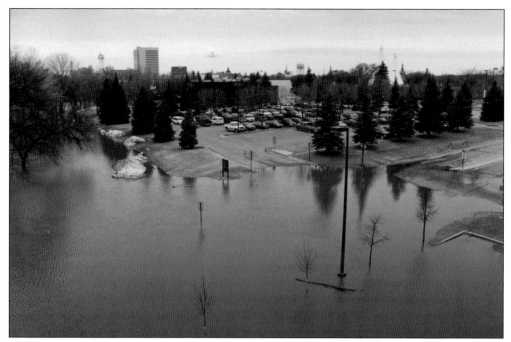

Flood-recovery efforts were still under way when another heavy flood struck in 2001. This time, the river rose to about 34 feet, but the two cities were better prepared. New routines had been developed for fighting floods. (Courtesy Alan Fricker.)

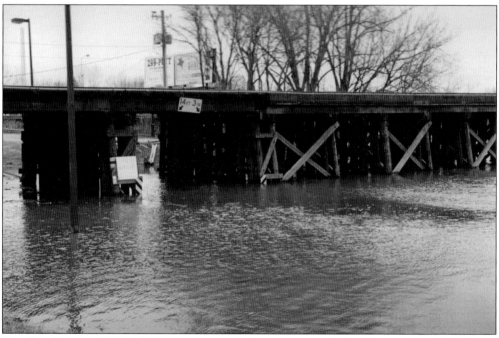

The floodwaters of 2001 did not exert as much pressure on the bridges as they did in 1997. Consequently, protection efforts were easier to put into place. (Courtesy Alan Fricker.)

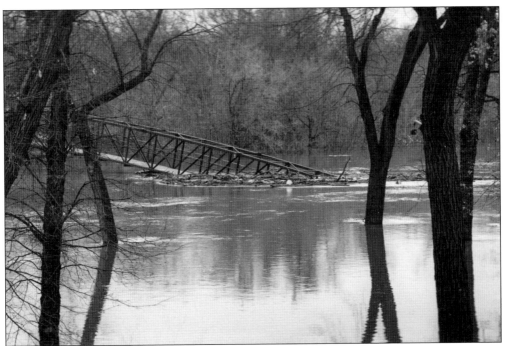

Walking bridges between Fargo and Moorhead were ordered to be closed during floods. This one was partially submerged during the 2001 flood. (Courtesy Alan Fricker.)

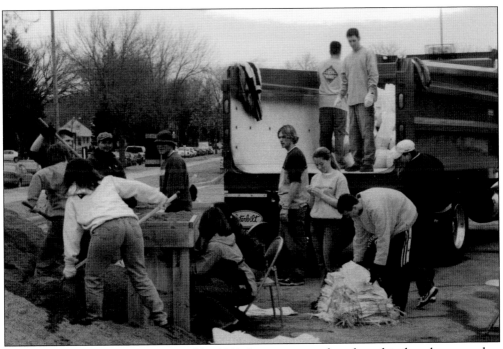

Sandbag crews were better organized by 2001, better equipped, and, as this shot shows, used to using cell phones to coordinate efforts and sending response teams to spots where immediate assistance was needed. (Courtesy Alan Fricker.)

The 1997 flood was thought of as a "once in a lifetime" event, but after the 2001 flood, regional flood models were revised. Residents of neighborhoods near the river now knew that they had to be prepared for a flood every spring. (Courtesy Alan Fricker.)

*Seven*

# THE FLOOD FIGHTERS

The 1997 flood was supposed to have been a 500-year flood (since several experts regarded that a similar conjunction of heavy, wet snow, rain, and fast melt would occur only one time in 500). That would prove to be incorrect. But, after the flood, the cities took no chances. New technologies and methods for organizing countermeasures became a priority in all the communities along the river. In both Moorhead and Fargo, for example, city authorities had used a comparatively small number of cell phones to improve communications during the 1997 flood. Cell phones proliferated among city employees after 1997, and elaborate procedures were drawn up to use the phones for immediate response teams to be sent to crisis zones. Once the 2009 flood began, Fargo officials immediately worked hand in hand with officials from Sprint and other telecommunication businesses to protect their facilities; if the messenger systems or computers went down, the flood battle could be lost.

The floods of 2009, 2010, and 2011 made up a protracted crisis. Because of an extended spell of wet weather, with heavy snow each winter and greater-than-average rain each summer, the floods were inevitably major ones. As one North Dakota official noted in 2011, "It's awfully tough to have to face a 'five-hundred-year flood' three years running." Each year, the river rose quiet as a cat's feet, the water spreading slowly but implacably. Fargo's population had grown significantly since 2000, which meant that the city now had more real estate to protect, particularly on its south side, where flat ground made overland flooding a major threat. The city also had another threat: the Sheyenne River entered the Red from the west, and it too was a river prone to flooding, carrying water across 500 miles of eastern North Dakota by the time it reached Fargo. Fargo authorities often had to fight it as well as the Red.

Fortunately, new communications had been matched by better coordination of the resources to meet the flood challenge. Moorhead's city planners, who had less vulnerable ground to protect, spent a decade buying out and removing structures along the riverfront, raising its dikes, and adding additional pumping stations. The flood threat was serious, but with state and federal assistance, and careful attention to detail, the city's government felt that the situation would be managed.

The greatest problem for both communities (and for all of the towns along the river) was that the extended wet spell made the crisis of 2009–2011 into a three-year flood campaign. The outcome of each flood over these years rested on how well the flood preparations met the challenges. From city officers, to technical experts, to the residents themselves, these three consecutive floods were the greatest test yet.

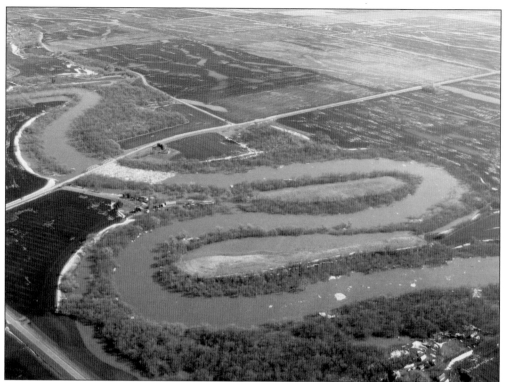

In 2006, the Red River flooded again, rising to over 37 feet. Even so, the advances in flood fighting limited the damage in Fargo and Moorhead. (Martin Rottler, University of North Dakota.)

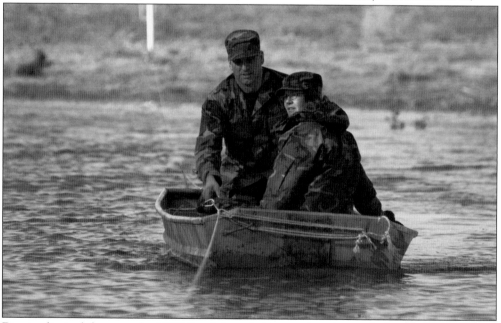

Despite limited damage, the 2006 flood forced this couple, who worked at Fargo's National Guard Air Wing, to commute to work by boat when water shut down the roads. (North Dakota National Guard.)

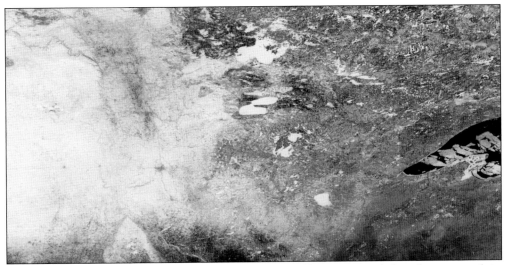

As winter was drawing to a close in 2009, weather satellites suggested that the snowpack in the Red River Valley would produce another major flood. On the far right in the image is the western tip of Lake Superior, while the heavy white area is the Red River Valley and eastern North Dakota. (Courtesy NASA.)

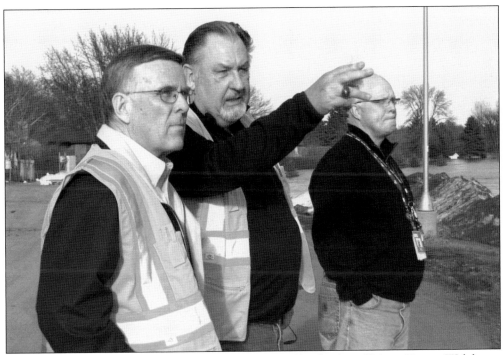

Forecasts for heavy flooding were confirmed, and some officials advised Mayor Dennis Walaker to evacuate parts of Fargo. Walaker (center, to the right of US senator Byron Dorgan) was convinced that new flood plans would preserve the city. (Dorgan Senate Office.)

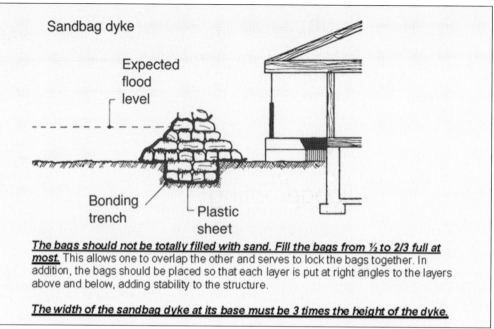

Sandbag dyke

Expected
flood
level

Bonding trench

Plastic sheet

_The bags should not be totally filled with sand. Fill the bags from ½ to 2/3 full at most._ This allows one to overlap the other and serves to lock the bags together. In addition, the bags should be placed so that each layer is put at right angles to the layers above and below, adding stability to the structure.

_The width of the sandbag dyke at its base must be 3 times the height of the dyke._

City governments distributed pamphlets providing emergency contact numbers and instructions for building sandbag dikes anchored in trenches. It would be difficult to cut even a shallow trench in the frozen soil. (Moorhead City Hall.)

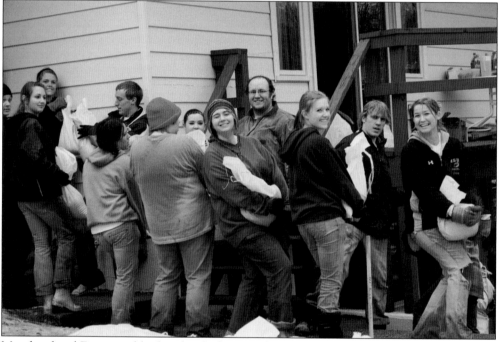

Moorhead and Fargo neighborhoods relied on youth to build the sandbag dikes. The Fargo city government promised a "free beer" to every person (of legal age) who joined sandbag teams around the city. The Dixie Brewing Company of New Orleans donated 1,000 cases of brew to the cause. (Minnesota State University, Moorhead.)

108

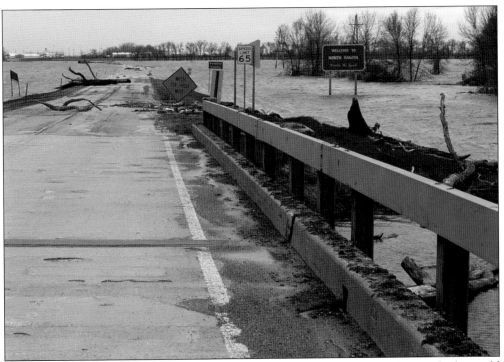

The melting snow covered roads to the point that only large trucks and military vehicles could easily be dispatched to threatened areas. Many roads, including highways, were reduced to one lane. Some rural roads closed altogether. (Ed Edahl, FEMA.)

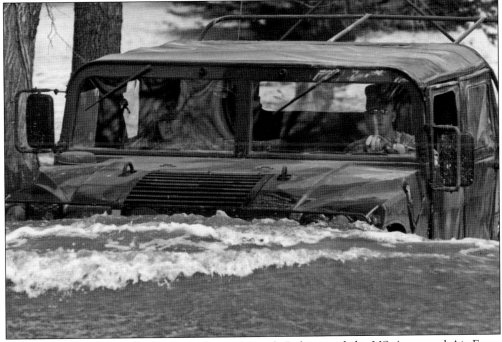

The National Guard in both Minnesota and North Dakota and the US Army and Air Force provided vehicles that could handle almost any obstruction. (David Lipp, US Air Force.)

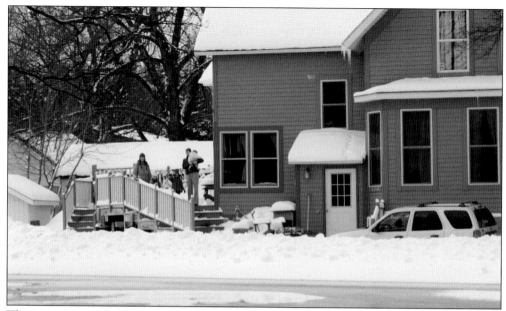

There was a considerable amount of snow still melting as rains pushed the river up to a new record high—40.8 feet. When the temperatures dropped overnight, light snows fell, and the cold threatened to open gaps in sandbag dikes. Many families were prepared to leave on short notice. (Jennifer LaVista, US Geological Survey.)

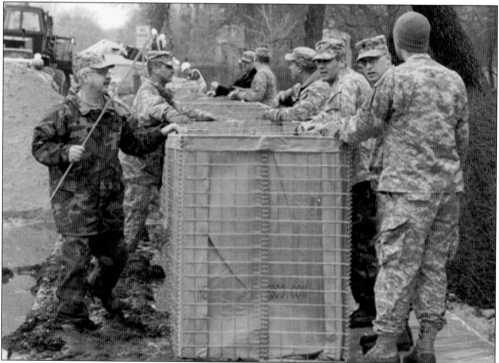

North Dakota National Guard troops built a Hesco dike. Made of steel mesh and fabric boxes filled with sand, soil, or gravel, Hesco barriers are quickly assembled, very sturdy, and can resist a significant amount of water pressure. (David Lipp, US Air Force.)

Mark Voxland, the mayor of Moorhead, spent most of the 2009 flood on his feet. With visiting endangered neighborhoods, consulting with other officials, and briefing the press twice a day, he felt there was too little time to get it all done. (Office of the Mayor, Moorhead.)

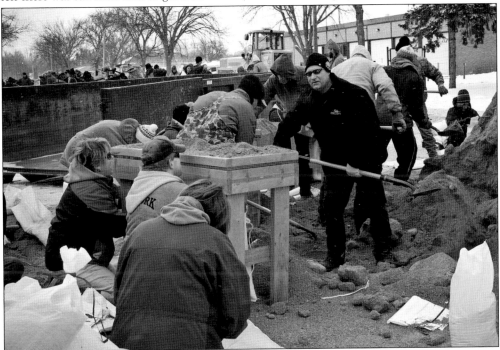

Neighborhoods united to help one another hold back the water. Sometimes, a line of bags no more than eight inches in height could do the job. Here, Moorhead's residents prevent catastrophic damage to the city. (Minnesota State University, Moorhead.)

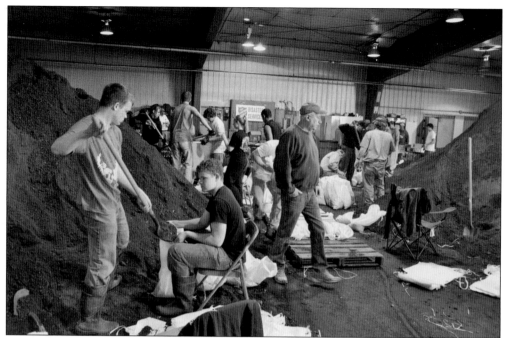

The threat to Fargo was more serious. Using North Dakota State University's large FargoDome arena, guardsmen and volunteers packed over three million sandbags for 12 miles of dikes to protect the city. "I don't care how old you are," Mayor Walaker said. "You haven't seen [an effort like] this in the valley." (Michael Raphael, FEMA.)

A snow-covered wall of sandbags protects a Moorhead home, on April 2, 2009. Fears calmed after the 40-foot crest receded, but additional rain led to a second crest of 42 feet, forcing evacuations on both sides of the river. (Mike Moore, FEMA.)

Lost and injured animals had always been a problem during the floods. Now, FEMA and state aides make arrangements with farms to shelter animals that might otherwise be lost. Volunteers serve at the shelters. (Andrea Booher, FEMA.)

Local and state officials used Internet podcasts to keep citizens informed of the flood situation, providing updates on everything from road closings to sewer usage. (Moorhead City Hall.)

Snowfall during the 2009–2010 winter made a second heavy flood likely, so planning began early. Computer simulations allowed residents to plan for their homes. (City of Fargo.)

After the previous flood, Fargo did not wait on events. In mid-March, city engineers began the constructing a clay dike along the vulnerable Second Street. (Michael Rieger, FEMA.)

Oxbow, south of Fargo, is a small community of 350 residents. Its mayor, James Nyhof, met with Army Corps of Engineers general Michael Walsh to make plans for a dike that would surround the entire community. Supplies ranging from bottled water to medicines were stockpiled. (Shannon Bauer, US Army Corps of Engineers.)

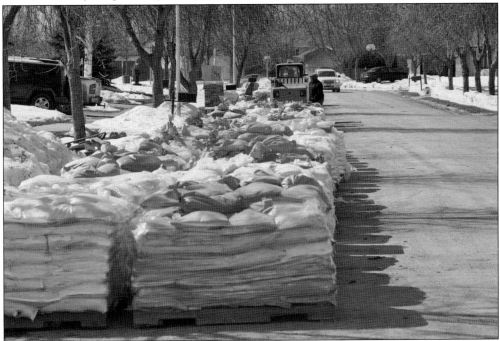

The City of Fargo reopened its "sandbag central" operation, using a locally designed sand filler that could produce 100,000 bags in a few hours. (Army Corps of Engineers.)

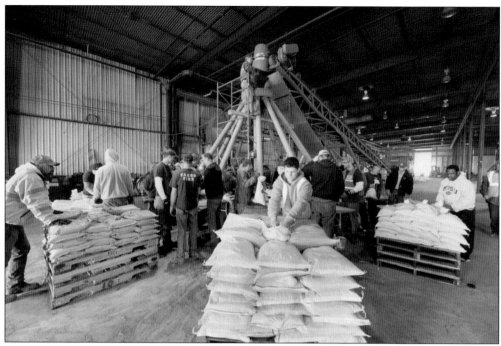

FEMA photographer Michael Rieger, on his second visit in 12 months, recorded the sandbag stockpiling. (Rieger, FEMA.)

Fargo's problems were made worse by the rising Sheyenne River, which had to be carefully monitored. (Shannon Bauer, Army Corps of Engineers.)

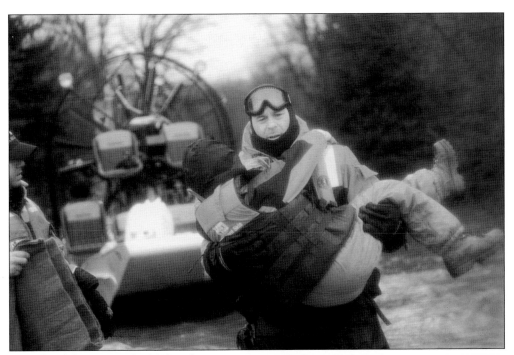

Most flood damage in the 2010 and 2011 floods was confined to property near the river. Boats manned by local authorities and the Coast Guard carried out several rescues from high water. Cass County sheriff Jesse Jahner helps in this rescue. (Cass County Sheriff's Office.)

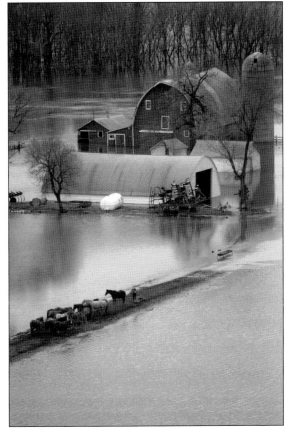

This farm, west of Fargo, was cut off by overland flooding during the 2011 flood. It took several vehicles and boats to rescue the family and animals. (US Coast Guard.)

Fargo mayor Dennis Walaker met with North Dakota governor Jack Dalrymple. Walaker had great experience with valley flooding. Others predicted the 2010 and 2011 floods might top all previous crests, but he disagreed, saying, "I don't see that much water out there." Each flood crested below the 2009 record. (Office of the Mayor, Fargo.)

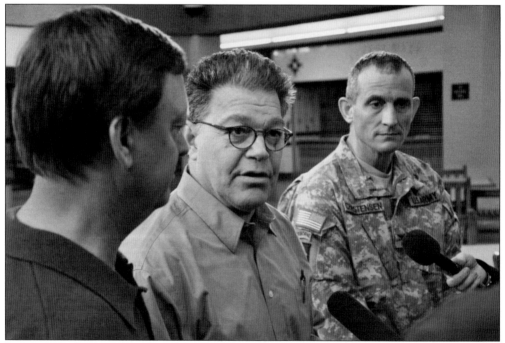

Soon after US Minnesota senator Al Franken (center) discussed Moorhead protection measures with Mayor Voxland, the third flood in three years began to recede. Plans for a "better solution" to annual flood emergencies soon began. (Franken Senate Office.)

Moorhead city officials met with representatives of all the organizations engaged in the flood fight in April 2011. After three consecutive heavy floods, everyone agreed that a more permanent solution was needed to protect the cities. (Moorhead City Manager's Office.)

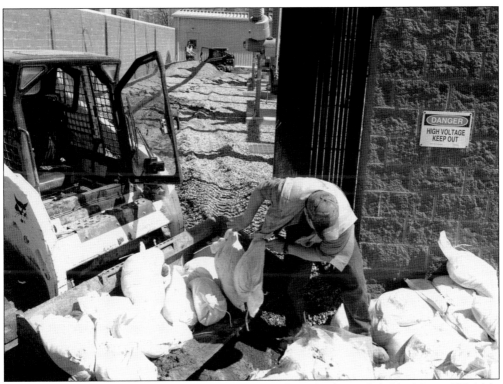

A Moorhead public service employee gathers wet sandbags for disposal. (Mike Moore, FEMA.)

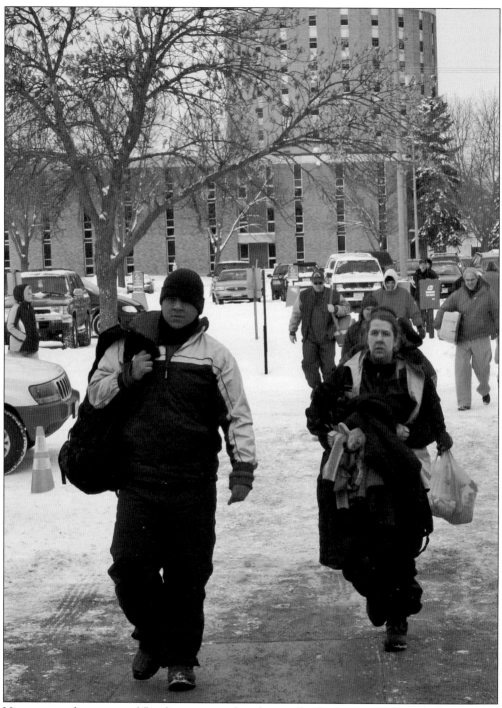

Victory over three years of flooding was owed to thousands of volunteers, who did whatever was necessary to get the job done. (Minnesota State University Moorhead.)

# *Eight*

# DECISIONS

Even as the residents were cleaning up from the 2009 flood, a group of local and state officials was meeting with members of the Army Corps of Engineers to study how to "reduce flood risk and flood damages in the Fargo-Moorhead metropolitan area." Many options were considered, including the construction of a massive holding reservoir, various kinds of diversions, and tall flood walls. Debate over the possibilities continued for two more years until ultimately, in July 2011, as the last problems from the 2011 flood were being attended to, the Fargo-Moorhead Metropolitan Area Flood Risk Management Project issued its report. The report recommended that a 36-mile diversion channel, built on the Fargo side of the Red River, was the most appropriate solution.

This diversion, with a "staging area to hold water" south of the cities, would begin "south of the confluence of the Red and Wild Rice Rivers," run west of the cities of Fargo and West Fargo, and then "re-enter the Red River north of the confluence of the Red and Sheyenne Rivers." The price tag for this project was estimated at about $1.8 billion. Flood damage costs were running to about $200 million on average for the recent floods. The plan and its price seemed acceptable to many, but not all those who lived in the region agreed with it.

Debate began immediately. Whose land would be taken for the diversion and the staging reservoir? How would the costs be financed? What risks would communities near Fargo-Moorhead face when the diversion water poured around the cities and back into the Red River? These were serious issues, and discussion has continued. In mid-2014, after the federal government authorized $846 million for the diversion in its Water Resources Reform and Development Act (WRRDA), the debate intensified. In August 2014, Minnesota's governor expressed his opposition to the proposed flood diversion as currently planned because it might "greatly benefit North Dakota but damage property in Minnesota." North Dakota officials urged him to reconsider.

What will ultimately happen with this issue remains to be seen. Most inhabitants of Fargo and Moorhead expect that they have not seen the end of flood dangers in the valley.

Melting ice chunks rest near Center Mall in Moorhead in March 2013. After a respite of just one year, the water rose again that spring, reaching a height of 33 feet. While not as threatening as the previous three floods, it was the fourth time in five years that high water mandated expensive precautions. (US Department of Agriculture.)

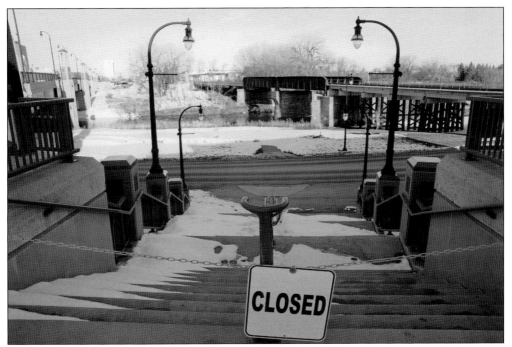

Moorhead's Third Street held snow on April 18, 2013. Flood precautions designed by the city uses Third Street as a catch basin for floodwater. The frozen Red River surrounds the bridge. (Nathaniel Minor, Minnesota Public Radio.)

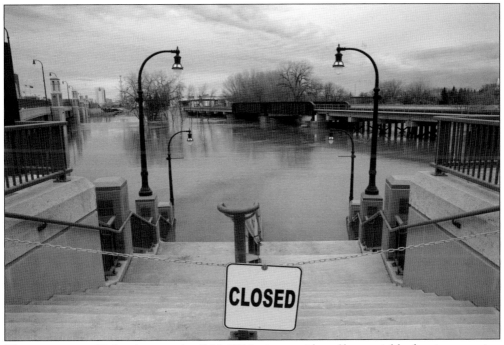

The same scene, 12 days later on April 30, 2013, gives an idea of how quickly the river can rise. (Nathaniel Minor, Minnesota Public Radio.)

Flood walls in Moorhead have been built as a backup to high earthen dikes. Gates will seal the walls, reinforced by sandbags, during a major flood. (Author's collection.)

This is a pump station near the dikes. During a flood, the pumps will channel large volumes of water away from any weak spots in the dike system. (Author's collection.)

The river was in partial flood along Moorhead's north side on June 21, 2014. After sustained rain for some two weeks, the river level was 25 feet, 7 feet above minor flood stage. Anticipating further rain, the weather forecasts raised worries that the river might crest above flood stage two or three times during the summer; however, dry weather followed. (Author's collection.)

The Sheyenne River meanders through West Fargo into the south Fargo suburbs. Many residents fear that the flood diversion may increase flooding of the Sheyenne and threaten their homes. Engineers have held numerous meeting to reassure residents. (Author's collection.)

The residents of Oxbow, south of Fargo, have begun construction of a ring dike (in background) to protect their homes. Nearby farmers fear that this may direct water toward their land; Minnesota residents across the Red River share similar concerns. (Author's collection.)

Fargo and Moorhead have raised their major dikes to protect the towns against a 44-foot crest. These dikes are deep as well as tall, and some are reinforced with concrete. (Author's collection.)